IMAGES
of America

DETROIT'S WARTIME INDUSTRY

ARSENAL OF DEMOCRACY

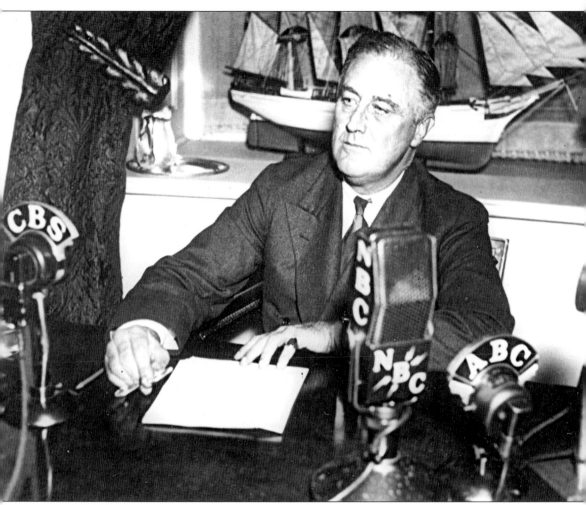

Franklin Delano Roosevelt (1882–1945), 32nd president of the United States, coined the term "Arsenal of Democracy" in one of his most notable fireside chat radio broadcasts to the nation on December 29, 1940. Radio was the new media when Roosevelt took office in 1933 at the depth of the Great Depression. A privately schooled patrician from the Hudson River valley, he seemed an unlikely leader of the common people, who familiarly called him by his initials, FDR. His New Deal administration spawned countless federal government agencies with often baffling acronyms such as NLRB, NRA, TVA, and WPA. During World War II, Americans became familiar with a whole new litany of "alphabet agencies," especially the OPA (Office of Price Administration) that came to govern their lives intimately. (Franklin D. Roosevelt Presidential Library.)

On the cover: The U.S. Army Detroit Arsenal, also known as the Chrysler tank plant, shown mass-producing M4 Sherman medium tanks around 1943, symbolizes the Arsenal of Democracy more than any other image. The Warren facility was noteworthy for the selection of Chrysler Corporation to build and manage it, for the amazing speed (seven months) in which it was erected and began production, and for its output of some 25,000 tanks during World War II—more than all Nazi Germany was able to produce during the war. (National Automotive History Collection, Detroit Public Library.)

IMAGES
of America

DETROIT'S WARTIME INDUSTRY
ARSENAL OF DEMOCRACY

Michael W. R. Davis

ARCADIA
PUBLISHING

Published by Arcadia Publishing
Charleston SC, Chicago IL, Portsmouth NH, San Francisco CA

Printed in the United States of America

Library of Congress Catalog Card Number: 2007931942

For all general information contact Arcadia Publishing at:
Telephone 843-853-2070
Fax 843-853-0044
E-mail sales@arcadiapublishing.com
For customer service and orders:
Toll-Free 1-888-313-2665

Visit us on the Internet at www.arcadiapublishing.com

CONTENTS

ACKNOWLEDGMENTS

As explained in the introduction, this book would not exist if the staff at Macomb County Community College in Clinton Township had not invited me to participate in their World War II program.

Among those at several archives, I want to single out Randy Talbot of the U.S. Army TACOM (tank and automotive command) in Warren. More than anyone else, Randy pointed me to William S. Knudsen's key role in the Arsenal of Democracy during World War II. I am much indebted to Mark Patrick, Barbara Thompson, and Laura Kotsis of the Detroit Public Library; Tom Featherstone and Elizabeth Clemens of the Walter P. Reuther Library, Wayne State University; Robert Clark and Mark Renovitch of the Franklin D. Roosevelt Presidential Library; Brandt Rosenbusch of the Chrysler Historical Collection, Auburn Hills; Laura Sullivan of the Ford Motor Company Archives, Dearborn; Larry Kinsel of the General Motors Corporation Media Archives, Detroit; Rutha Beamon of the National Archives, Suitland, Maryland; Ron Williamson of the Jacksonville Naval Air Station in Florida; and Bill Phillips of the Michigan Department of Transportation, all of whom I felt went beyond the normal call of duty to assist me.

Several friends loaned me books or photographs from their personal collections, namely John Bluth, Mike Skinner, and Jim Wagner, fellow trustees of the National Automotive History Collection, and Maureen McDonald. Dr. Charles K. Hyde of the Wayne State University Department of History provided wise counsel, as he had provided for my previously published histories. James Sponseller, a retiree from Fisher Body Division of General Motors, heard about my project and volunteered both photographs and history.

Judith K. Christie and Martha K. McKenney of the Knudsen family helped me to understand several steps in William S. Knudsen's government service during the war.

Finally I want to acknowledge my wife Karen's infinite patience when I become involved in a book project. Her copyreading skills applied to the final product are invaluable, because no writer can edit his own material.

The following is the key to photograph credits and sources in parentheses at the end of each caption: National Atomic Museum, Kirtland Air Force Base (NAM); John A. Bluth (JAB); Chrysler Historical Collection (CHC); Michael W. R. Davis (MWRD); Ford Motor Company Archives (FMCA); General Motors Corporation Media Archives (GMCMA); National Automotive History Collection, Detroit Public Library (NAHC); Menominee Range Historical Foundation, Iron Mountain (MRHF); James Sponseller (JS); William S. Knudsen Collection, Detroit Public Library (WSK); Michigan Department of Transportation, Lansing (MDOT); Jacksonville Naval Air Station Archives (JNAS); Franklin D. Roosevelt Presidential Library (FDR); Walter P. Reuther Library, Wayne State University (WPRL); Michael Skinner (MS); TACOM Archives, U.S. Army, Warren (TACOM); National Archives and Records Administration (NARA); and James K. Wagner (JKW).

INTRODUCTION

The genesis of *Detroit's Wartime Industry: Arsenal of Democracy* began with a telephone call from Macomb County Community College, northeast of Detroit, right after Thanksgiving 2006. Could I deliver a lecture on the Arsenal of Democracy as part of a four-month-long exhibition and program series on World War II that the college was sponsoring beginning in February?

After brief consideration I assented but then asked, "Why me?" Because, they told me, I included sections on the Arsenal of Democracy in each of my three previous Arcadia photographic histories about General Motors, Chrysler, and Ford.

May 10, 1940, the day that German forces invaded the "Low Lands" of Holland and Belgium, was my ninth birthday, so my firsthand memories of World War II are dim at best. And, rather than of Detroit in the war, those memories are from my hometown of Louisville, Kentucky, which was only peripherally involved, like most other cities, with war industries.

I owe much of my initial knowledge of the Arsenal of Democracy to an article on the subject I commissioned from Hugh McCann, a friend and former *Newsweek* and *Detroit News* reporter, for a centennial book I produced in 1995 for the Engineering Society of Detroit. Another source was the archive of William S. Knudsen papers that his family donated in 2004 to the National Automotive History Collection (NAHC) at the Detroit Public Library.

Since I would have to pull together dozens of images for my illustrated talk at Macomb County Community College, it was only a short step to proposing a photographic history book about the Arsenal of Democracy to Arcadia Publishing.

From several of my previous books, I knew the NAHC photographic collection contained many images of military vehicles and that the *Detroit News* collection at Wayne State University's Walter P. Reuther Library could be mined for historical community photographs. To tell the Arsenal of Democracy story fully in *Life* magazine picture style, I also was able to access images in several widely dispersed corporate and government archives and several private collections.

As I dug deeper into research on the subject, I learned details about one Detroiter's unique contribution from 1940 through 1945 to the American war effort: William S. Knudsen was a Danish immigrant with an amazing record of success in the automotive industry, rising from a machinist in a Buffalo metal-working plant to become a top production manager at Ford Motor Company. After a falling out with Henry Ford, he moved to Chevrolet in 1922, where he climbed the ladder to presidency of General Motors in just 15 years.

Franklin D. Roosevelt was elected president of the United States in 1932, and his resulting New Deal administration countering the Great Depression was marked by perpetual conflict with big business, of which General Motors was the biggest. Nevertheless, six weeks after the German invasion of Denmark and Norway, and exactly two weeks after the blitzkrieg against the Low Lands, on May 24, 1940, Roosevelt telephoned Knudsen with a request he come to a meeting at the White House. There Roosevelt asked him to resign from General Motors to head the buildup of U.S. defense production. Knudsen promptly assented.

"I suppose he agreed to this because the Germans had invaded Denmark, his native land," I asked Knudsen's only surviving child, Martha McKenney. "Oh, that wasn't it," she told me. "He called a family meeting to tell us he was leaving General Motors to work for the government. We were dumbstruck by his announcement. Finally I spoke up—I was a 20-year-old college student, the youngest—and asked him why." Her father's simple explanation: "This country has been good to me, and I want to pay it back."

But there was another question she could not answer. How was it that, of all the people in the country, Roosevelt had called upon a stranger and philosophical adversary who, as it turned out, unquestionably possessed the best credentials in the nation to carry out the formidable task of launching the Arsenal of Democracy? I found the answer in the memoir of another Danish immigrant who became a power in the automotive industry, Charles Sorenson. Sorenson's *My Forty Years with Ford* related that when Roosevelt toured Ford's Willow Run B-24 plant in September 1942, Sorenson had the opportunity to satisfy his own curiosity about Knudsen's appointment. Roosevelt, he related, told him that Bernard Baruch, an investment banker and noted presidential advisor who directed U.S. war production in World War I, had suggested the name, which the president initially had rejected.

This account starts with Detroit's contributions in World War I, a very different effort from that of World War II because there was no interruption of civilian production. Moreover, some historians now are coming to the view that World War II was merely an extension of World War I after a 15-year intermission, a struggle between nationalisms and fading empires in which the United States had little direct interest but was drawn in anyway.

Detroit and the automotive industry were by no means the only major city and industry constituting the Arsenal of Democracy. Detroit's importance, however, is encapsulated in the following passage from the military history Web journal Olive-Drab:

> World War II was the first war in which massive numbers of trucks completely changed the equations of mobility for warfare. The production capability of the U.S. automotive industry poured out hundreds of thousands of jeeps, trucks and armored vehicles. This made it possible for the U.S. and its allies to overwhelm the Axis with men and supplies, moving forward at a rate never before possible.
>
> Particularly in Europe, where the land warfare was most suitable for mobility, the ability to maneuver and supply by truck was a decisive advantage to the Allied armies in World War II. Although the German Army had pioneered mobile warfare in the late 1930s, they never became motorized to the extent of the Allies.

The automotive industry possesses three key characteristics, often not recognized, that define its irreplaceable role in national defense: (1) mastery of mass production, (2) a network of large and small suppliers, and (3) a huge workforce of experienced production and skilled workers, especially those in critical tool-and-die trades.

While this book emphasizes the automotive industry's role, the Arsenal of Democracy included aircraft and ship producers, munitions makers, steel and other metal companies, and countless large and small businesses across the nation turning out uniforms, tents, mess kits, and all the military's supply needs. The experience of the Arsenal of Democracy provided countless examples of companies and industries, normally very competitive and often secretive, cooperating with one another for the common cause of victory. There were snags and disputes to be sure, but a winning spirit seemed always to carry the day.

This history of the Arsenal of Democracy also relates the war's impact on the home front, experiences that changed the lives of Americans and their relationship with big G government forever.

Michael W. R. Davis
Royal Oak, Michigan
July 2007

One

THE FIRST WORLD WAR

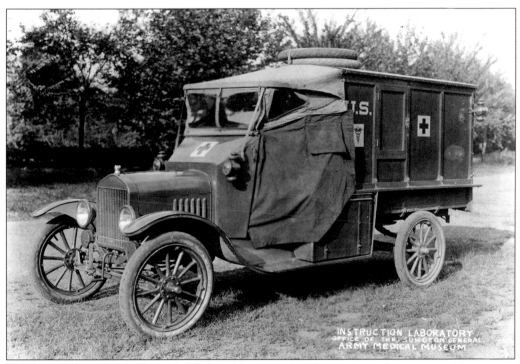

The homely but reliable Ford Model T had been produced in such prodigious quantities—some 1.4 million cars by the end of 1914—that, as adapted by Allied forces in World War I, it also became Detroit's most familiar product behind the battlefields of three continents. Here is an ambulance version developed for the U.S. Army Medical Corps. One problem was that the stretchers for sick and wounded were longer than the body behind the front seat, so that the handles stuck out the rear. (NAHC.)

The U.S. Army began investigating motortrucks to replace horse-and-mule transport as early as 1904. Motorcars were still new and considered experimental, and few trucks had been developed. Shown here on Atlanta's Peach Tree Street in March 1912 is a Signal Corps photograph of the army's first road test of a truck. The make is unidentified. (NAHC.)

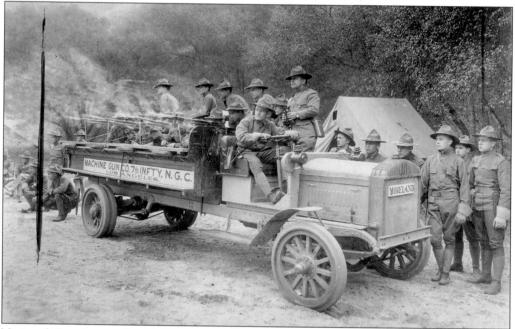

National Guard units of civilians more familiar with the rapid advance of motor transport tried to promote their acceptance. Here a California National Guard unit promotes use of a locally made Moreland truck as a bed for a battery of machine guns in 1915. The machine gun was also a relatively new technology and quickly revolutionized warfare as it mowed down unprotected cavalry and infantry on European battlefields. (NAHC.)

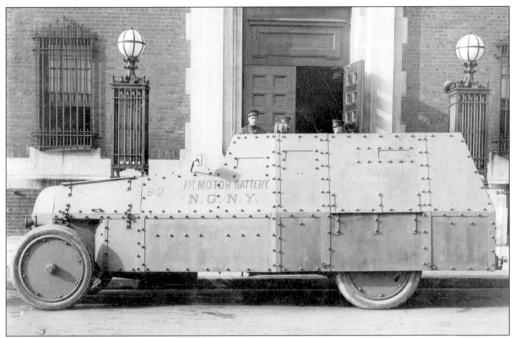

New York City's National Guard organized its 1st Motor Battery around this early armored car on a Locomobile chassis. The idea of an enemy shooting back had now registered, as this vehicle features complete armor plating, except for the ever-vulnerable wheels and tires. If such a car could be driven cross-country over shell hole–pocked terrain, it might prove useful in attacking deadly German machine-gun nests. (NAHC.)

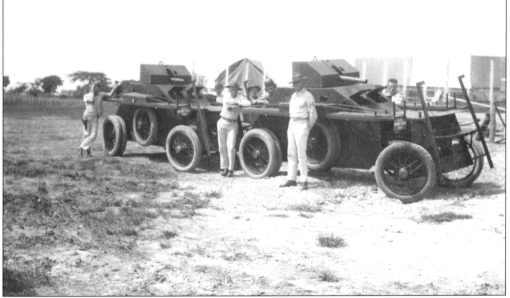

Here U.S. Marines pose with a different form of armored car in the World War I period. Note that, in addition to the turret with probably a 37-millimeter cannon, the rear wheels are doubled like a truck to carry the added weight. While the tires are unprotected, the radiator appears to be armored. The purpose of the rig on the front is unknown, as is the make. (NAHC.)

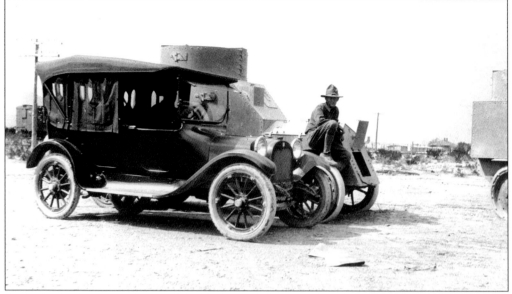

The U.S. Army embraced motor vehicles on its 1916 Mexican Punitive Expedition against revolutionaries and bandits along the southwestern border. This shows Gen. John J. "Black Jack" Pershing's Dodge touring car as well as unidentified armored cars in the background. California guardsmen brought their Moreland trucks to the fight where they were used as cargo carriers and convinced the army of their practicality. (CHC.)

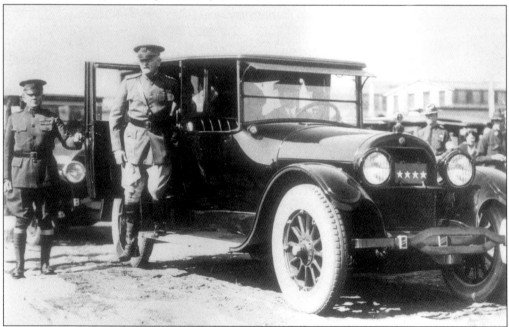

When Pershing became commander of American forces in France after the United States declared war against Germany in April 1917, he chose a statelier Cadillac as his staff car, shown here. Note the four stars of his rank on the front plate. Vehicles now were used for troop movements, including an armada of Paris taxis drafted to transport soldiers hastily to the front to halt a German advance. (GMCMA.)

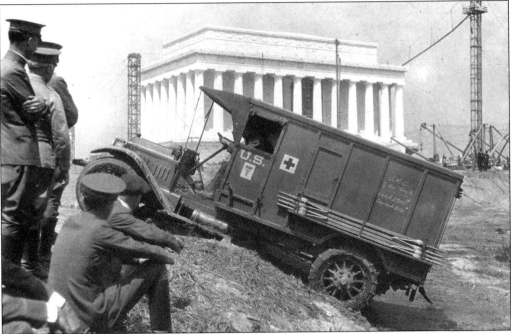

In this historic photograph taken in September 1918—almost at war's end, though no one knew it—the army is testing a GMC ambulance in the excavation for the decorative reflecting pond at the Lincoln Memorial, then under construction in Washington, D.C. Chains are mounted on the rear drive wheels to provide traction on the muddy embankment. (NAHC.)

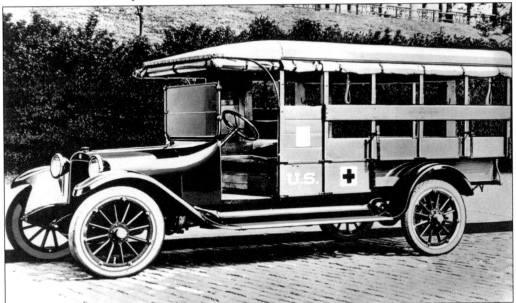

Here is the Dodge version of a World War I ambulance. Buick, among others, also supplied ambulances to the Allied powers. Ambulances picked up wounded from field hospitals behind the lines and whisked them to hospital trains for transport to rear-area base hospitals. There ambulances carried them from trains to wards and clean beds. The efficiency and speed of motor ambulances undoubtedly contributed to higher survival rates. (CHC.)

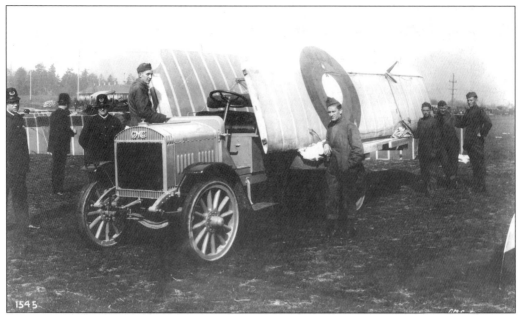

Among the more unusual uses for a motortruck during the Great War, as it was originally termed by the British, was this GMC modified to carry what was then known as an aeroplane. Note that the truck has neither headlamps nor bumpers. Perhaps it was only operated on an aerodrome. (NAHC.)

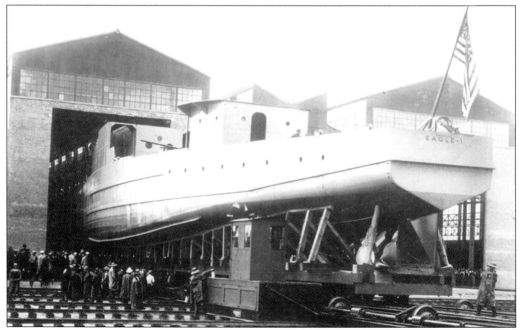

When America was drawn into war by German submarine warfare, Henry Ford promised he could build submarine chasers at a one-a-day rate. He got the government contract early in 1918, but volume production at the Rouge plant of Eagle boats—this shows the first one off the line—came too late for the war effort. Notably, a Ford manufacturing expert named William S. Knudsen was in charge of Eagle production. (MWRD.)

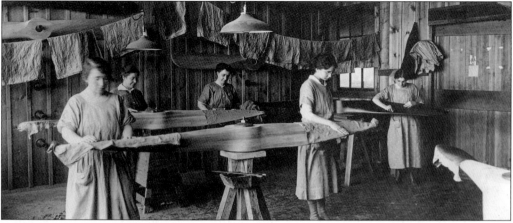

Industry supplier Fisher Body Company, later part of General Motors (GM), became a major manufacturer of aircraft at a west side Detroit plant during World War I. Here women workers prepare wooden propellers for one of the two aircraft types, the DeHavilland DH-4 and the Curtiss JN-4 "Jenny" trainer, built by Fisher. Fisher delivered 1,000 aircraft before war's end on November 11, 1918. (JS.)

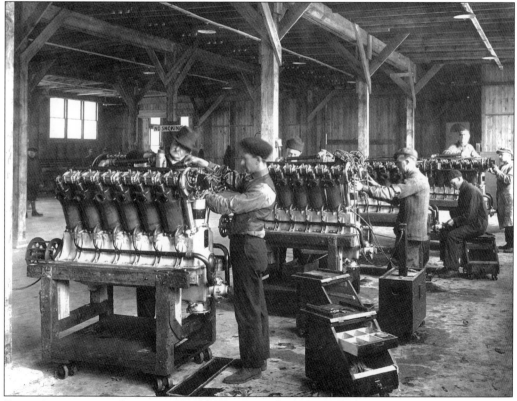

Detroit's major contribution to World War I may have been these mammoth 400-horsepower V-12 Liberty aircraft engines being assembled here. They were a cooperative design project of Packard, Ford, and Lincoln engineers and were also manufactured by Buick, Cadillac, and Marmon. The Allies ordered some 22,500 Liberty engines for a variety of airplanes, but the war ended before they affected the outcome. (JAB.)

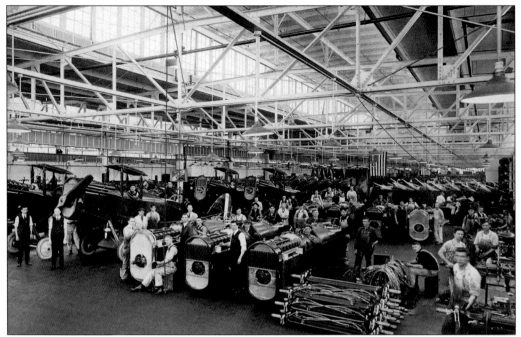

Here at Fisher's Detroit plant, three DeHavilland DH-4 scout bombers lie in the midst of the production process, without landing gear and wings. Others on the left already have "legs." Detroit would learn a lot about mass-producing military aircraft a quarter century later in World War II. Note the 12-cylinder Liberty engines already mounted in the biplane fuselages. (JS.)

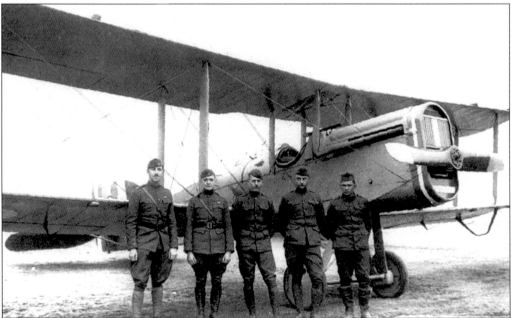

Five members of the U.S. Army 278th Observation Squadron pose with their DH-4 and its Liberty engine at an aerodrome "somewhere in France" in 1918. This is an early model DH-4 with the pilot cockpit well forward beneath the wing. Later it was moved rearward to improve pilot and crewman communications. (JAB.)

Two

BETWEEN THE WARS

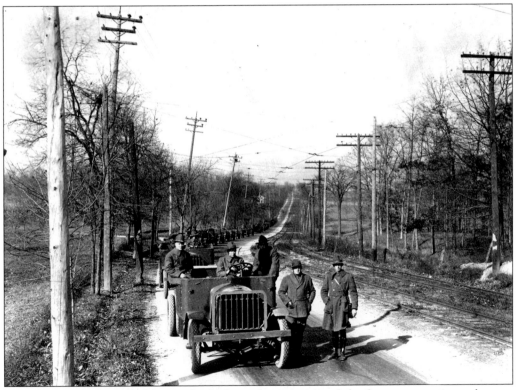

On July 7, 1919, the U.S. Army embarked on what was termed the first transcontinental motor convoy, consisting of 24 officers, 15 observers, and 278 men, riding on a variety of 81 motorized vehicles ranging from motorcycles to five-ton trucks. They followed the often-unpaved Lincoln Highway (U.S. 30) from near Washington, D.C., to San Francisco over the next 62 days in a quest to evaluate different makes and sizes of trucks. The army's own unique World War I Standard B "Liberty," is shown here at the front of the convoy. (NAHC.)

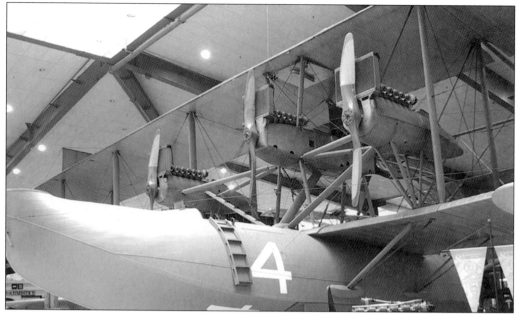

Another postwar venture was the first flight across the Atlantic, accomplished on May 8–31, 1919, by the U.S. Navy flying boat NC-4, powered by four of Detroit's Liberty engines. The flight, sponsored by Assistant Secretary of the Navy Franklin D. Roosevelt, departed from Rockaway, New York, and reached Plymouth, England, via stops in Massachusetts, Nova Scotia, Newfoundland, the Azores, Portugal, and Spain. The aircraft is shown here at the Naval Air Museum in Pensacola, Florida. (MWRD.)

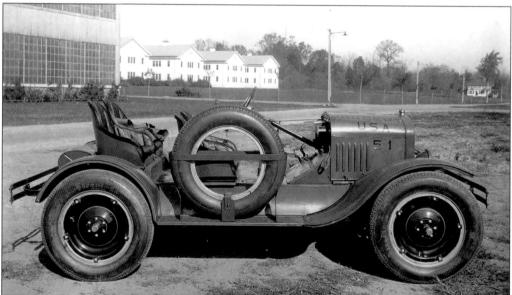

Although the U.S. Army had demobilized after World War I, interest continued in the development of special-purpose military vehicles rather than just civilian vehicles painted olive drab. Here is a 1923 experimental, one-of-a-kind cross-country reconnaissance car based on the Ford Model T. Note the seats positioned rearward, the relatively low profile, and the oversize wheels and tires. (NAHC.)

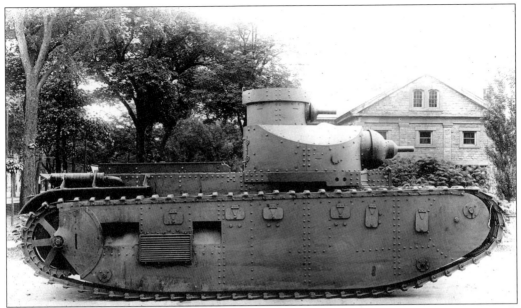

The military tank, or land ship as it was first called, was introduced to battle by the British about halfway through World War I. By war's end, Britain and France had produced 6,500 tanks, the United States 84, and Germany only 20. Between the wars, the U.S. Army encouraged development of experimental tanks in line with advancing vehicle technology, such as this *c.* 1927 medium tank, possibly a Packard model. (NAHC.)

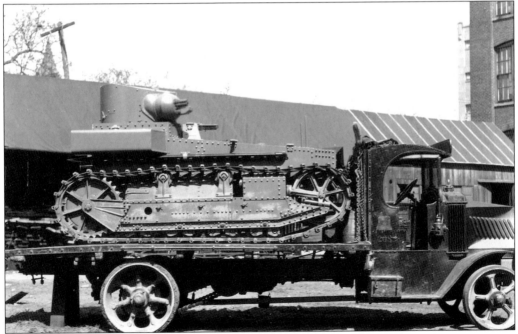

The Cunningham automobile company of Rochester, New York, was a builder of custom-bodied luxury cars much favored by the Hollywood elite of the silent film era. About 1930, it built this experimental light tank for the army that was so small it could be carried on the back of a flatbed truck. This became a forerunner of America's first World War II tank. (NAHC.)

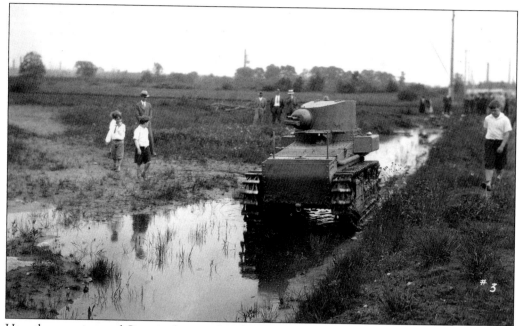

Here the experimental Cunningham tank is shown being tested in a very public venue, with small boys and men watching. In 1933, Gen. Douglas MacArthur reported to the War Department that the army had only a dozen experimental tanks plus a few units left over from World War I that were not considered serviceable—in essence, no armored force. (NAHC.)

Meanwhile, the U.S. Army was also following development of trucks, which had made great advances during the 1920s. Pictured here is an experimental GMC 6x6 (that is, with three driving axles) two-and-a-half-ton army truck of 1931 vintage, vastly more modern in virtually every respect than the "Liberty" truck, which led the 1919 transcontinental convoy. (NAHC.)

The so-called half-track was a spin-off from the conventional army truck, with rear-axle-powered crawler treads rather than rear wheels and rubber tires, sort of a half-tank, in this example unarmored. The GMC version shown here was built experimentally for the army in 1935. Its family resemblance to the two-and-a-half-ton truck in the previous photograph is obvious. (NAHC.)

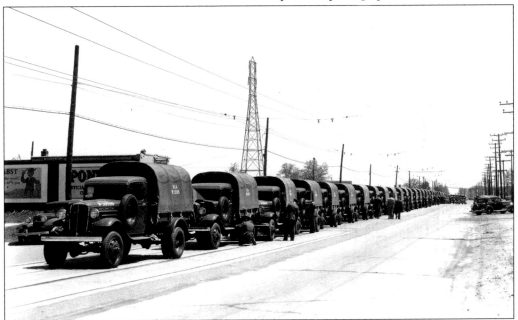

To replace worn-out or outmoded vehicles, the army continued to buy small numbers of essentially civilian trucks during the years between the two world wars. Here is a long line of 1936-model GMC one-and-a-half-ton trucks in military garb, lined up near the factory in Pontiac for delivery. (NAHC.)

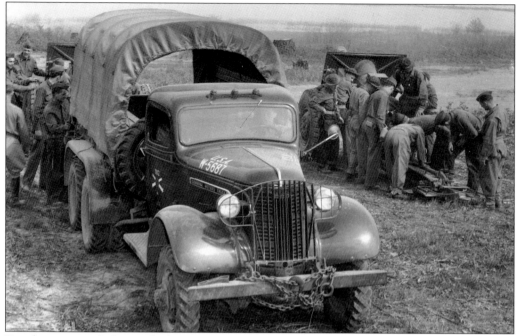

Development work during the late 1930s continued on 6x6 two-and-a-half-ton trucks. The U.S. Army wanted a standard workhorse truck with common specifications and interchangeable parts to minimize maintenance and supply. It made economic sense to choose one make for this task, and GMC's standard civilian model of this size was favored. This shows a 1937–1938 vintage GMC "on duty" with a field artillery unit. (NAHC.)

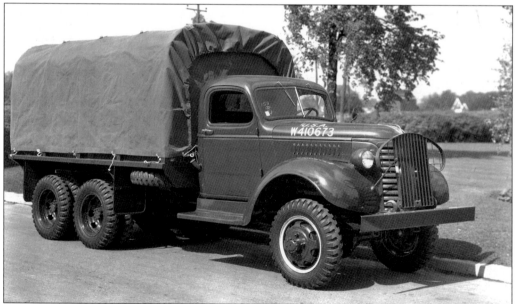

The 1939-model GMC 6x6 army prototype pictured here shows "annual" changes from the previous model shown above, including a two-piece windshield and civilian truck–like shiny grille bars. In keeping with military practice, there is a grille covering the front to protect the radiator and headlamps from brush when the vehicle goes off-road. (NAHC.)

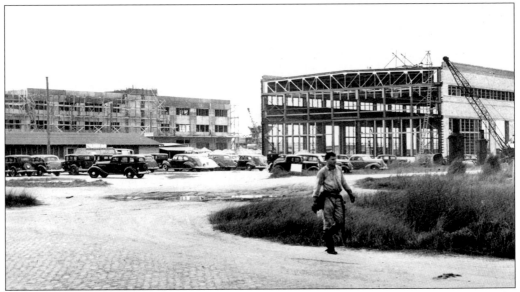

Detroit's manufacturing enterprises were not the only firms gaining defense contracts. The Albert Kahn Associates architectural firm—designer of many automobile plants as well as office buildings and homes—also had designed facilities in World War I for key U.S. military aerodromes. In 1939, Kahn was once again employed to design structures such as these at the Jacksonville Naval Air Station in Florida. (JNAS.)

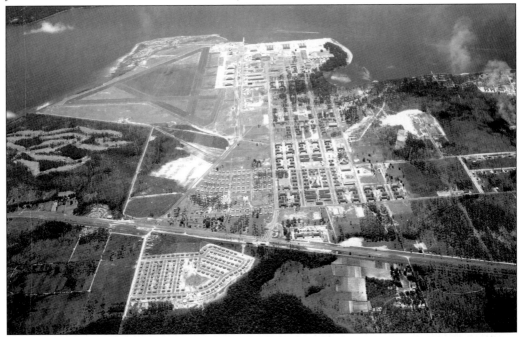

Between 1939 and 1942, the U.S. Navy hired Detroit's Albert Kahn firm to design buildings for air stations along the East Coast of the United States, in the Caribbean, and on several Pacific Ocean islands, including Alaskan locations. Initially these were mainly for seaplanes or amphibian aircraft, hence the location along the St. Johns River of the Jacksonville Naval Air Station shown in this aerial photograph. (JNAS.)

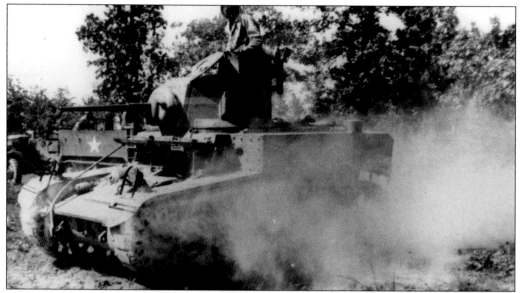

On the eve of World War II, the U.S. Army still viewed tanks as adjuncts to infantry, typified by this lightly armored M2/M3/M5 tank being tested. Developed at the Rock Island Arsenal from a 10-year-old Cunningham design, it was armed with only a 37-millimeter cannon and .30-caliber machine guns, proving vulnerable from antitank weapons and other tanks. It was the only tank the United States produced in volume before mid-1941. (TACOM.)

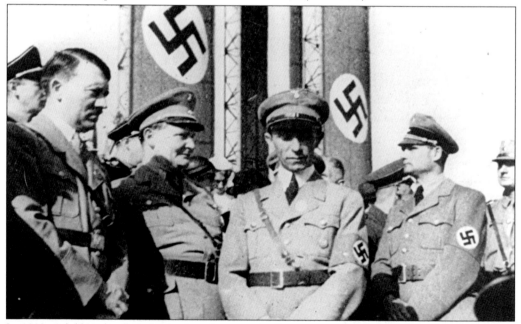

In 1933, Adolf Hitler (left, hatless) took power in Germany, overthrowing democratic controls. In violation of peace agreements, he rearmed the German military with special attention to armor and aircraft. Secret police, government-promoted anti-Semitism, and concentration camps became trademarks of his dictatorship under the National Socialist German Workers (Nazi) Party. Sequentially, Hitler led his Third Reich to take over the Rhineland, Austria, and part of Czechoslovakia, and to intervene in the Spanish Civil War. (FDR.)

Three

WORLD WAR II
"DEFENSE" PRODUCTION

The 1939–1940 portion of this timetable helps explain developments in the United States causing the Arsenal of Democracy to crank up. Under Pres. Franklin D. Roosevelt, America tried to maintain its neutrality in the face of strong sympathy on one hand for its World War I allies and, on the other, an outspoken pacifist movement backed by a combination of Communist followers on the left, Nazi sympathizers on the right, and strict isolationists in the middle. (MWRD.)

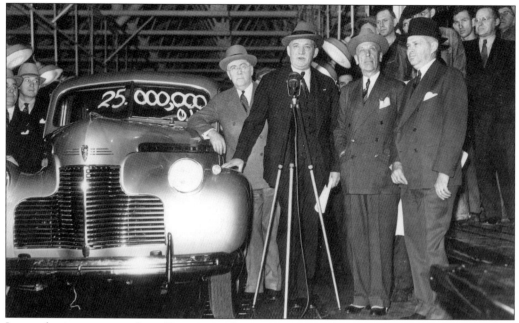

It was business as usual in Detroit as the automotive industry recovered from the Great Depression. Here William S. "Big Bill" Knudsen (at microphone) celebrates production of GM's 25 millionth car on January 11, 1940. Knudsen (1879–1948), president of GM since 1937, was a Danish immigrant and machinist who spent a decade at Ford Motor Company establishing its branch assembly plants before he joined Chevrolet in 1922 to built up its manufacturing capacity. (WSK.)

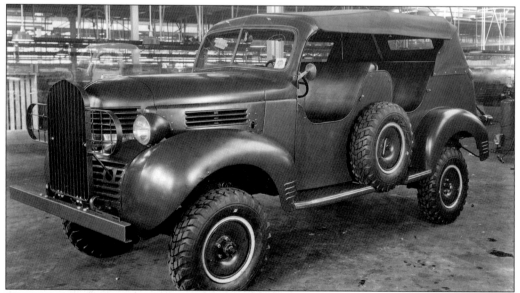

This prototype four-wheel-drive Dodge VC-1 scout car for the U.S. Army, photographed on February 28, 1940, demonstrates that development work continued on military vehicles in a period when national policy opposed spending for defense production. Later versions of this vehicle went to war as command cars. It is considered an ancestor of today's sport utility vehicles. (NAHC.)

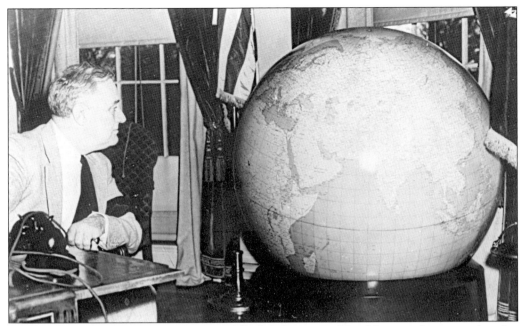

Shocked by Nazi success in overcoming Allied defenses, on May 24—exactly two weeks after Germany invaded western Europe—Franklin D. Roosevelt invited Knudsen to Washington, where he asked him to resign from GM to manage the buildup of American defense production. Because of his intimate knowledge of the automotive industry and mass production, Knudsen was perfect for the job. Bernard Baruch, who headed U.S. war production in World War I, suggested Knudsen's appointment. (FDR.)

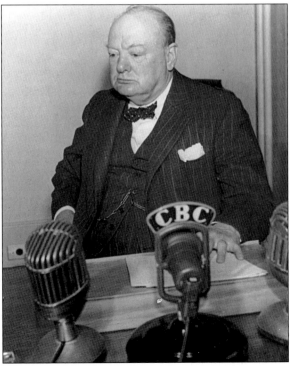

Meanwhile, Winston S. Churchill (1874–1965) was appointed British prime minister and endeavored to hold the British-French alliance together in the face of battlefield failures. His stirring and defiant speeches strengthened the spirit of the British people, and he and Roosevelt went on to lead a new—and ultimately victorious—alliance between their two countries. (FDR.)

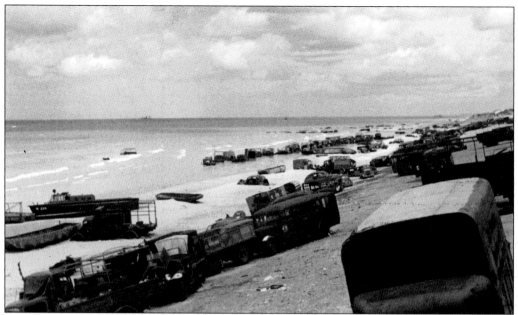

Trapped at the end of May 1940 on the English Channel coast by the German army, the British had the choice of surrendering or evacuating by small boats, leaving their equipment behind. Between May 26 and June 4, some 338,000 troops escaped. This captured German war photograph shows some of the 25,000 Allied vehicles abandoned on the beach. (NARA.)

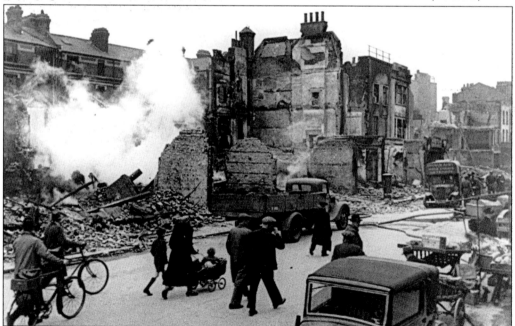

While Pres. Franklin D. Roosevelt was pushing Congress to authorize billions for defense production and to institute a peacetime military draft "for preparedness," on July 10, 1940, the Germans launched the Battle of Britain—aerial attacks on English cities—from the conquered lands of the continent, hoping to bring the country to its knees. This shows results of German bombing in London. (FDR.)

Concerned about German airpower and whether, if Britain surrendered, Nazi forces might soon be in Canada, U.S. Army chief general George C. Marshall (left) and his Air Corps commander, Gen. H. H. Arnold, decreed that no defense plants should be located within 250 miles of the United States coast or border. William S. Knudsen persuaded Marshall that America's industrial powerhouse rested in Rochester, Buffalo, Cleveland, Toledo, Detroit, and Flint and got the order amended. (FDR.)

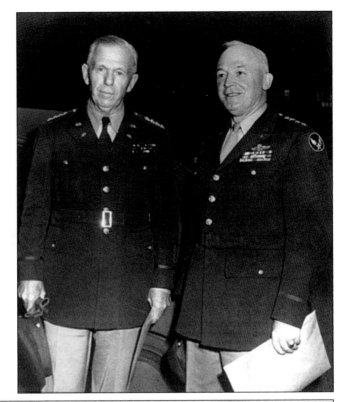

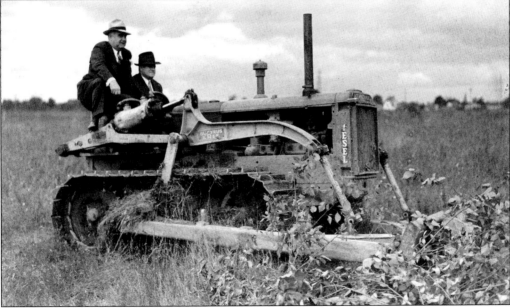

As defense production czar, Knudsen turned to K. T. Keller, president of Chrysler Corporation and both a neighbor and former manufacturing colleague at GM, to create a new plant to mass-produce 30-ton medium tanks. The contract was signed on August 15, 1940, and shown here with Keller at the bulldozer controls, groundbreaking took place on September 11 in a farm field in the Detroit suburb of Warren. Thus began the Detroit Arsenal Tank Plant. (CHC.)

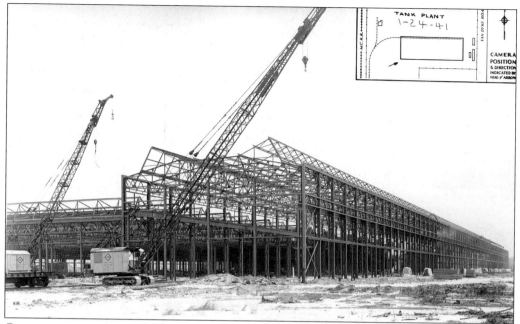

Construction on the enormous tank plant proceeded at a torrid pace, unfettered by material shortages in late 1940 and early 1941. The Warren plant was the first of the automotive industry's defense plants and only the third large factory built in the Detroit area since before the Depression. As indicted in the upper right corner, this view of the steel framework faces to the northeast. (CHC.)

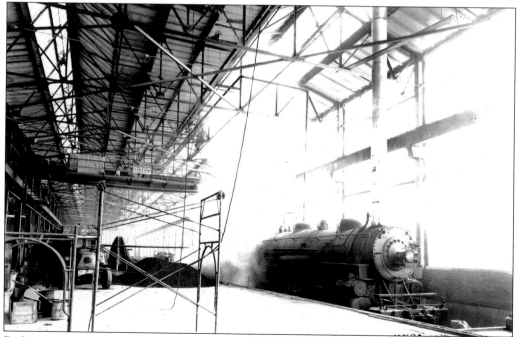

By January 1941, the Detroit tank plant had roofs and some walls but still no heating plant. A steam locomotive was brought in on the plant's railroad siding to provide heat and power for the huge building, at the time the largest such factory in the world. (CHC.)

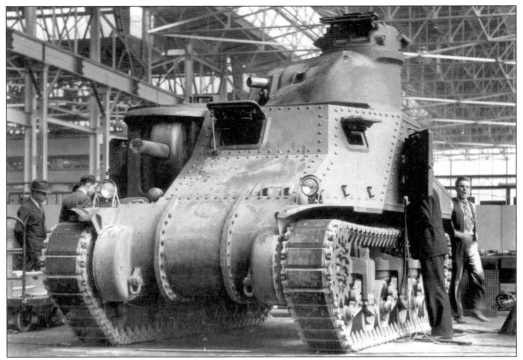

This first pilot model M3 medium tank came off the line at the Detroit tank plant on April 24, 1941, miraculously just seven months after groundbreaking. Chrysler employees at the plant chipped in to buy the first one as a gift to the U.S. War Department. Regular production commenced a couple of months later after army inspections showed the Chrysler-built tank was acceptable. (TACOM.)

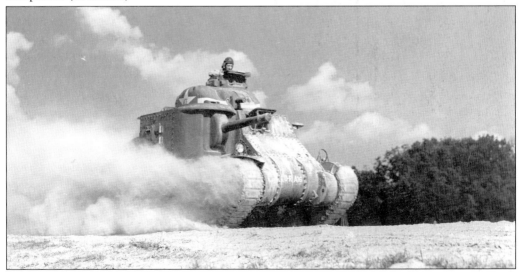

The Detroit Arsenal's M3 Lee/Grant medium tanks also were being manufactured at the Rock Island Arsenal in Illinois and the American Locomotive Company in Schenectady, New York. Although tested in the United States, as shown in this photograph, the M3 was yet to experience combat conditions. Early-production M3s were quickly shipped to British forces fighting Italian and German armies in North Africa for their baptism of fire. (NAHC.)

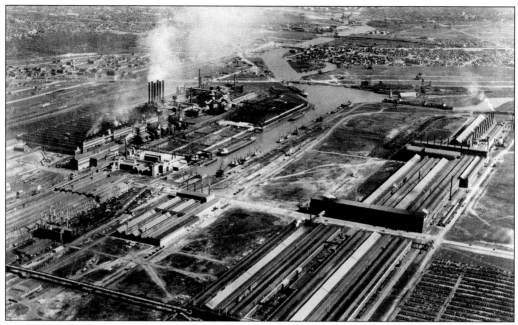

Ford's mammoth Rouge plant was coveted by the U.S. War Department from the beginning. Edsel Ford was eager for defense work but was frustrated by his aging and senile father, Henry, who maintained pacifist views even after Pearl Harbor. Henry reneged on a promise in June 1940 to manufacture British Rolls-Royce engines but acquiesced later to building a new plant here at the Rouge plant for U.S. Pratt and Whitney engines. (NAHC.)

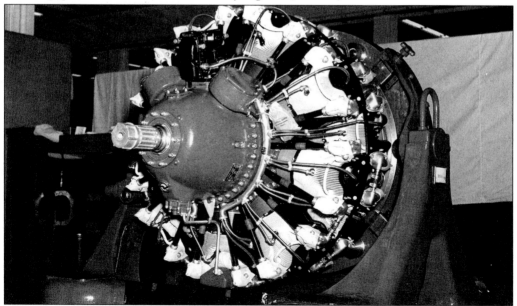

On August 16, 1940, Ford contracted to mass-produce Pratt and Whitney's 18-cylinder R-2800 aircraft engine, shown here. Ground was broken for a huge $14 million plant on September 22 and, despite an unrelated labor organizing strike at the Rouge plant, the first production engine was completed on August 23, 1941. Ford built more than 50,000 of the engines for such planes as the B-26, C-46, P-47, Corsair, Hellcat, and Bearcat. (NAHC.)

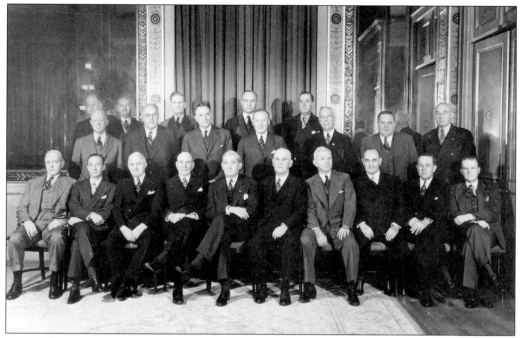

In October 1940, William S. "Big Bill" Knudsen—so nicknamed because of his imposing six-foot-two-inch height—met in Detroit with directors of the Automobile Manufacturers Association, shown posing here, to enlist their organized participation in taking on a mass of defense contracts. They were his people, so to speak, and he knew their operations and abilities intimately. The industry captains agreed to subordinate new model automobile development to defense production. (NAHC.)

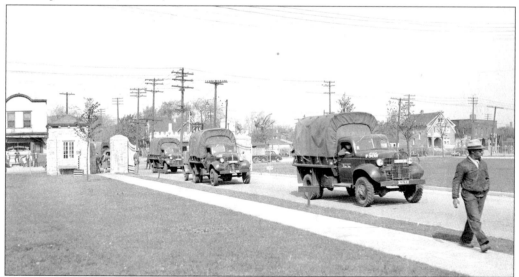

The army reactivated Fort Wayne, a 19th-century installation along the Detroit River within the Detroit city limits, to act as a center for automotive production purchasing and supply. Here, on October 15, 1940, army one-and-a-half-ton Dodge trucks arrive with troops and equipment to reinvigorate the historic landmark for its role, which would also include processing recruits and inductees, in World War II. (WPRL.)

In mid-July 1940, the U.S. Army Quartermaster Corps asked for proposals to develop and build "light reconnaissance vehicles." Only three companies responded, Bantam of Butler, Pennsylvania, Willys-Overland of Toledo, Ohio, and Ford of Dearborn. Here is a 1940 Bantam prototype of what was to evolve into the famous World War II jeep. The chassis is loaded with sandbags to simulate the weight of the complete vehicle. (NAHC.)

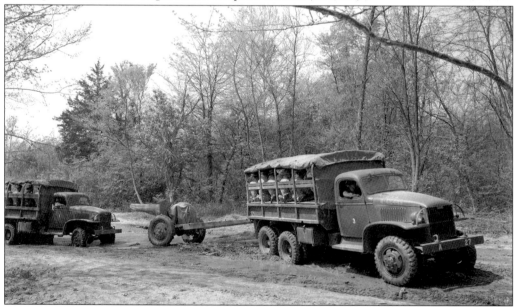

With funding flowing forth from Congress, the U.S. Army was able to order a large number of GMC 6x6 trucks, which became the standard army transporter of men and materials. By the summer of 1941, they were widely in service, as shown in this photograph of "Six-Bys," as the soldiers called them, hauling 75-millimeter field guns at Fort Knox, Kentucky. (NAHC.)

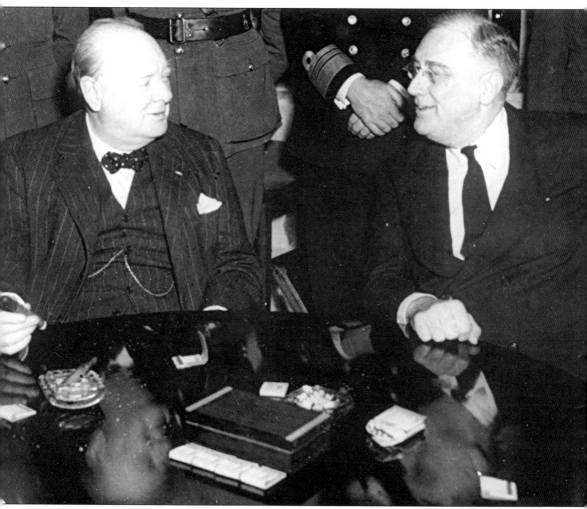

Winston Churchill (left) and Franklin D. Roosevelt were drawn even closer together after the Axis powers signed their Tripartite Pact in September 1940. Britain was the lone outpost remaining against the aggressor dictatorships. Buoyed by his election in the fall to an unprecedented third term as president, Roosevelt became even more outspoken in support of Great Britain. In his December 29, 1940, trademark informal fireside chat over nationwide radio, Roosevelt introduced the expression "Arsenal of Democracy." He said, in part, "This is not a fireside chat on war. It is a talk on national security. . . . I want to make it clear that it is the purpose of the nation to build now with all possible speed every machine, every arsenal, and every factory that we need to manufacture our defense material. We have the men—the skill—the wealth—and above all, the will. . . . We must be the great arsenal of democracy. . . . Our country is going to be what our people have proclaimed it must be—the arsenal of democracy." (FDR.)

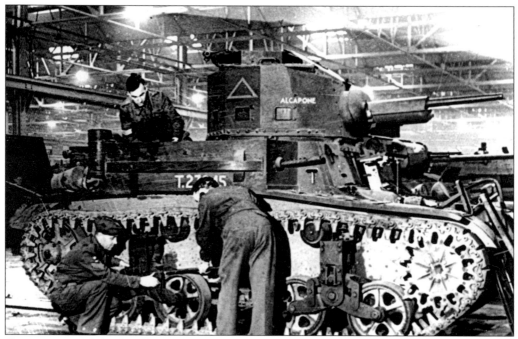

Congress passed the Lend-Lease Act on March 11, 1941, providing a mechanism to resupply Great Britain and its allies, such as the Netherlands, in exile from Nazi occupation. Russia became eligible for U.S. aid in June 1941 when Adolf Hitler trashed his treaty with Joseph Stalin and invaded the Soviet Union. In this photograph, British soldiers are examining a newly arrived American Lend-Lease M3 light tank. (FDR.)

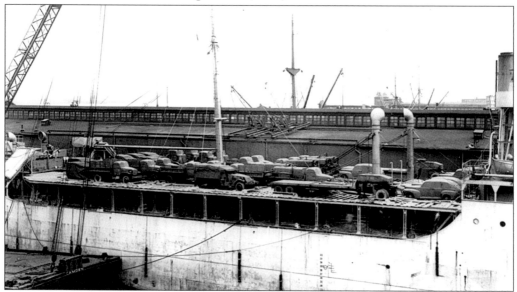

Even though American armed forces were being built up rapidly in 1941 through National Guard activations, the Selective Service Act (draft), and enlistments, vital equipment was diverted from the United States to supply the Allies. This freighter is so fully loaded for shipment that an auxiliary deck has been added to carry the Lend-Lease trucks, half-tracks, and sedans seen on top. (FDR.)

As a result of dramatic news reporting about German bombings of Britain and a natural support for English-speaking peoples, there was great sympathy for the Allied cause and an outpouring of patriotism in America well before the United States became actively involved. Many young men enlisted in the service of their choice rather than waiting to be drafted into the U.S. Army as privates. Two prominent Detroit examples in the spring of 1941 were Henry Ford's grandsons, Henry II and Benson. Henry II is shown standing in his U.S. Navy lieutenant's uniform and Benson in his U.S. Army Air Corps captain's uniform. Henry II served at Great Lakes Naval Training Center north of Chicago. However, he was released from active duty in the summer of 1943 because of a crisis in management at Ford Motor Company following the death of his father, Edsel Ford, and the importance to the government of Ford maintaining war production. (MS.)

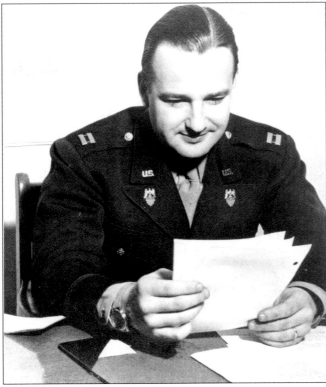

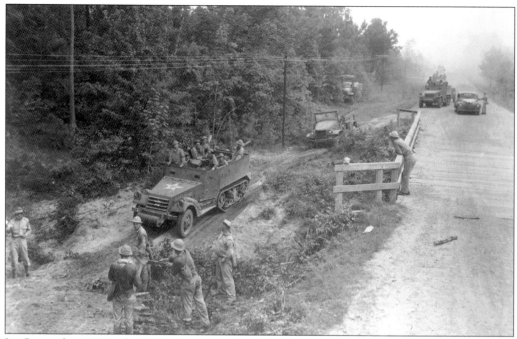

In September 1941, the U.S. Army conducted extensive maneuvers in Louisiana. Here a motorized unit is pretending the bridge is down, or incapable of carrying the weight of heavy military vehicles, and that it is necessary to go off-road to bypass it. Leading the column is a White Motors (a Cleveland truck maker) half-track. (NAHC.)

When an army has adopted motor vehicles in place of horses and wagons, it discovers that roads inevitably present traffic bottleneck problems, as shown in this picture from the 1941 Louisiana maneuvers. Learning to cope and the value of military policemen (MPs) to keep traffic moving were invaluable lessons for subsequent war years, especially for the Red Ball Express that kept Allied armies supplied in the European theater in 1944–1945. (NAHC.)

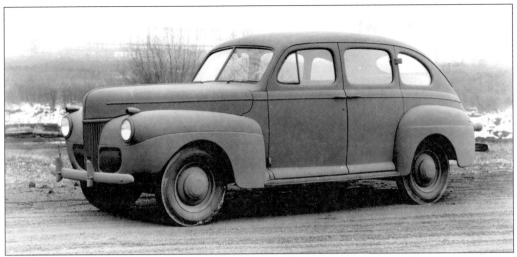

Along with specialized military vehicles, the army needed thousands of civilian-type passenger cars for use in noncombat operations. They typically were stripped-down four-door, low-priced sedans like this 1941 Ford, or similar Chevrolets and Plymouths. Bright trim was painted over—olive drab for army and gray for navy—and special "blackout" front and rear lamps installed. (MS.)

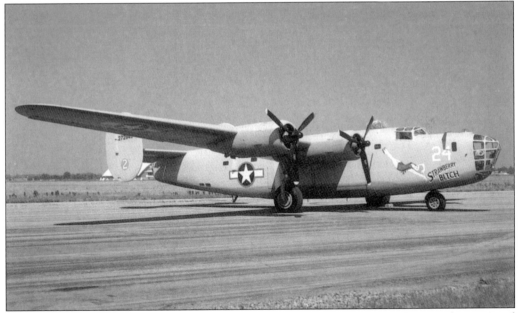

In January 1941, Ford Motor Company was asked if it could mass-produce this new four-engined B-24 Liberator bomber designed by Consolidated Aircraft of San Diego. Ford production chief Charles Sorenson had to partially redesign the aircraft so it could be built on a moving assembly line—yet to be constructed—and the company took on the challenge at what became the fabled Willow Run plant. (MS.)

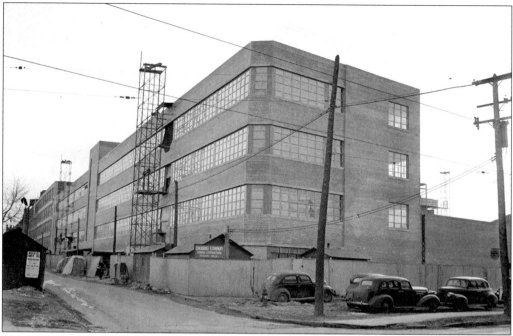

When Henry Ford refused to build Rolls-Royce engines in 1940, the Packard Motor Car Company took the contract. Like other nonautomotive defense products, it had to be redesigned for mass production. This is a building Packard erected in Detroit for the work. Packard-produced V-12 Rolls-Royce Merlin 27-liter engines powered a variety of aircraft, including Britain's Hurricanes and Spitfires and late-model U.S. P-51s. (WPRL.)

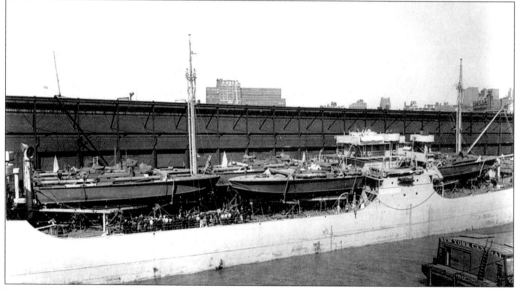

In parallel, Packard produced its own-design 4M-2500 V-12 Marine engines to power the U.S. Navy PT (patrol-torpedo) boats shown on the deck of this freighter, probably bound for South Pacific waters where they saw extensive action from 1941 to 1945. The Packard engine was derived from the World War I Liberty aircraft engine. John F. Kennedy, the 35th president of the United States, served on such Packard-powered PT boats in the Solomon Islands. (FDR.)

A naval training center was established at Ford's Rouge plant in 1940 to train sailors in repair and maintenance of mechanical and electrical equipment. The school headquarters, shown here, and barracks were located on the Rouge River, northwest of the ship basin. Sailors marched to the Dearborn assembly plant area for technical training. Other automakers and major suppliers also provided specialized technical training for the U.S. armed forces. (MS.)

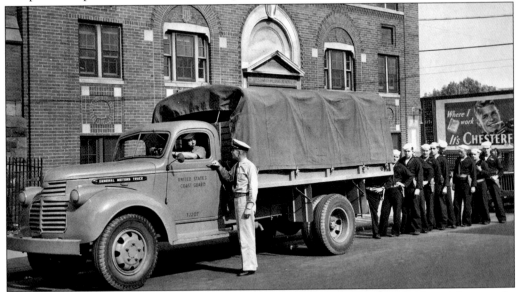

Other U.S. armed forces besides the army were acquiring civilian-type vehicles in the months before Pearl Harbor. Here is a 1941–1942 GMC one-and-a-half-ton truck assigned to the Coast Guard. GMC light and medium trucks shared many components with Chevrolet but had a distinctive grille and were powered by a slightly larger overhead-valve in-line six-cylinder engine. (NAHC.)

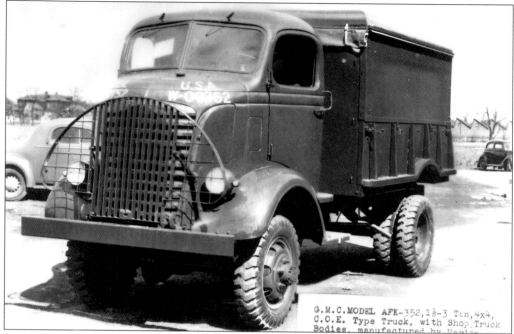

G.M.C. MODEL AFK-352, 1½-3 Ton, 4x4,
C.O.E. Type Truck, with Shop Truck
Bodies, manufactured by Marion

In the prewar period, civilian-type trucks like this cab-over-engine GMC model were also ordered by the military with custom-designed, often limited-production bodies for special purposes. The army truck pictured here featured a Shop Truck body manufactured by Marion Metal Products Company. Like a child's puzzle, it opened up (below), and its roofed-over space could be utilized for a variety of field jobs. The truck was rated at one-and-a-half- to three-ton capacity, with four-wheel (4x4) drive. After mid-1942, army trucks, regardless of manufacturer, were ordered built to common specifications and appearance for a given type. Automotive-wise servicemen, of course, knew which was a Chevy and which was a Ford by their familiar engines and instrument panels. (NAHC.)

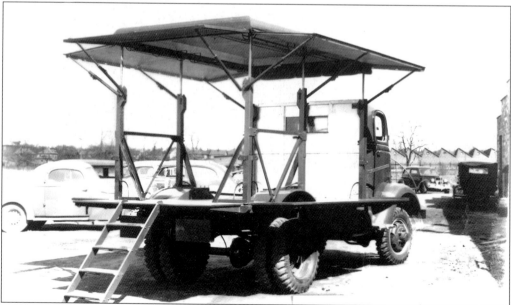

Four

PEARL HARBOR AND "WAR" PRODUCTION OF TANKS

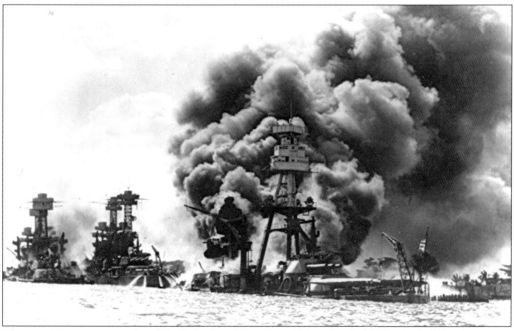

The sneak Japanese attack on Pearl Harbor, Hawaii, on December 7, 1941, crippled the American battleship fleet and adjoining army and navy air bases. It also galvanized Americans in ways the Japanese never anticipated. Germany and Italy declared war on the United States within days. In the Far East, Japanese forces overwhelmed U.S., Philippine, British, and Dutch defenders. However, the Japanese navy had attacked the wrong targets at Pearl Harbor. Battleships were largely made obsolete by aerial warfare. Attackers fortunately failed to catch the U.S. aircraft carriers in port. (FDR.)

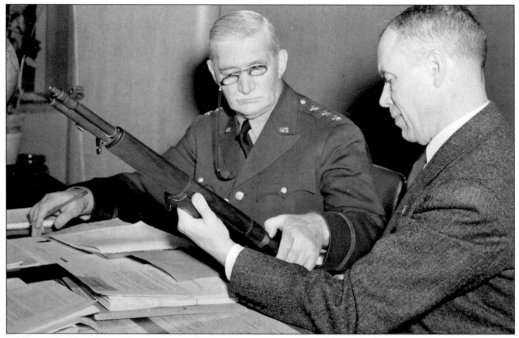

William S. Knudsen, former president of GM, was now charged with directing the nation's conversion from defense to war production. Nevertheless, he encountered bureaucratic and political barriers in Washington and among some of the military, so Pres. Franklin D. Roosevelt commissioned him a three-star lieutenant general. Here, in uniform for the first time on February 10, 1942, he examines the new M-1 Garand rifle with then assistant secretary of war Robert P. Patterson. (WSK.)

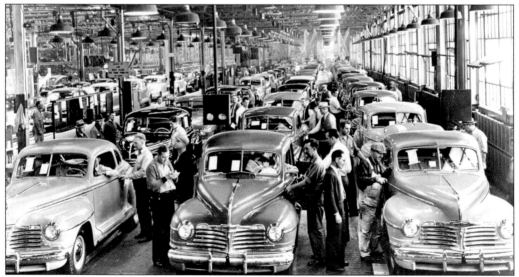

In Detroit, civilian car production, such as these 1942 Plymouths shown at the assembly line end of the Lynch Road plant, was winding down. Shortages of materials like chrome plating diverted to aircraft needs caused most late-1942 models to have painted rather than bright trim, indicating that this photograph was taken early in the production run, probably late summer in 1941. (NAHC.)

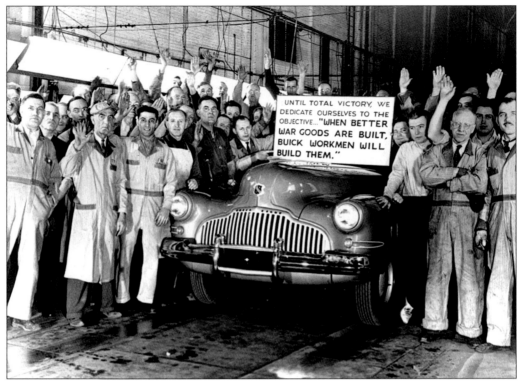

The automobile manufacturers agreed to end civilian production by the end of January 1942 or as soon as they ran out of parts. This is Buick's final civilian car on February 3, 1942. Ford was last to end civilian production, on February 10 for cars and on March 10 for trucks. One GM plant reported it was able to start war production only 29 days after ending civilian output. (MWRD.)

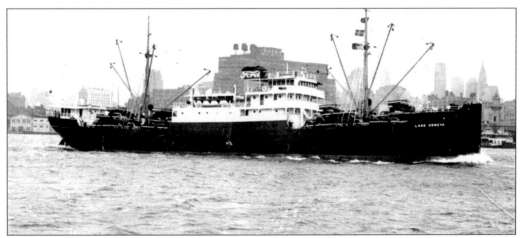

Ford Motor Company owned a fleet of 33 vessels in 1941 to move shipments on the Great Lakes and to overseas plants. The government began "drafting" Ford's ships that fall for Lend-Lease shipments. Ford's *Lake Osweya*, shown here, was torpedoed and sunk with all hands (a Ford crew) near Nova Scotia on February 19, 1942, the first of five Ford ships to meet the same fate. (MWRD.)

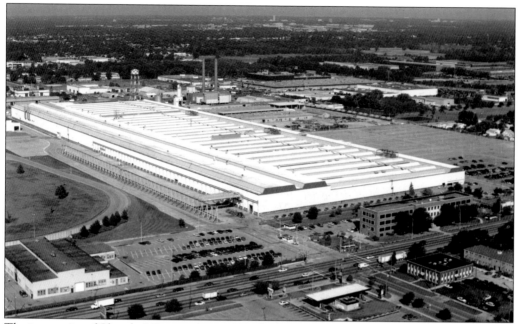

The immensity of Chrysler's Detroit Arsenal Tank Plant in Warren is shown in this contemporary aerial photograph. Until a larger Russian tank plant was constructed, Warren had the world's largest such factory and ultimately produced more tanks, some 25,000, than all of Nazi Germany. Also manufacturing M3 tanks at the war's beginning were such locomotive makers as American Locomotive and Baldwin, as well as the U.S. Army's Rock Island Arsenal. (TACOM.)

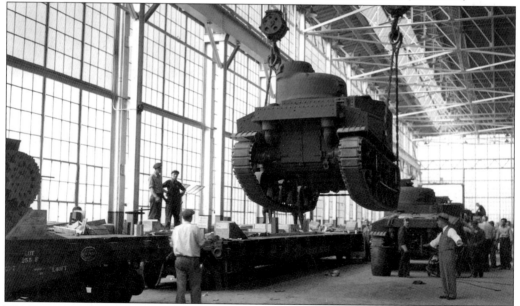

The Detroit tank plant's output of M3 medium tanks continued forcefully with automotive-type "annual model changes" to improve their fighting ability. Already newer-design M4s were coming off the line at other manufacturers, mainly locomotive companies such as Lima and Pacific Car and Foundry. Here an M3 is lifted onto a railroad flatcar for delivery to a U.S. Army base or to docks for shipment overseas to U.S. allies. (NAHC.)

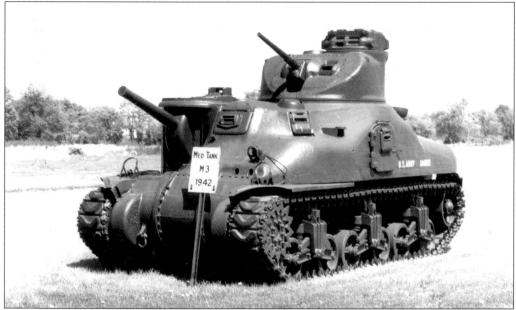

This photograph illustrates design changes on an M3A1 with a cast upper hull, probably made by Baldwin Locomotive. Earlier M3s had riveted hulls (like the lower front of this M3 and the first Chrysler-built tank shown on page 31). When early M3s were struck by a projectile, even if it did not penetrate, the upper hull's rivet heads popped off, wounding crew members. (TACOM.)

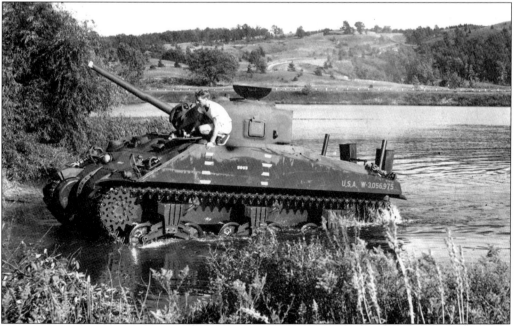

A new tank, the M4 Sherman shown here being water tested at GM's Milford Proving Ground, was developed based on "lessons learned" from problems with the M3. A turret that now could rotate a full 360 degrees was the most obvious change, and upper hulls were either cast or welded, like this one. The other advance was substitution of automotive-type engines for aircraft engines, which were needed to power airplanes. (NAHC.)

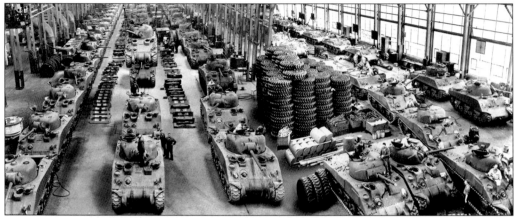

The Detroit Arsenal Tank Plant switched in July 1942 from making M3s to building M4 Shermans, the mainstay of American and British armored units for the rest of the war. The welded upper hull, turret, and unusual 30-cylinder Chrysler-built engine were new, but otherwise the lower part was simply a modification of the M3. M4s were armed with a 75-millimeter cannon plus a .50-caliber and two .30 caliber machine guns. (NAHC.)

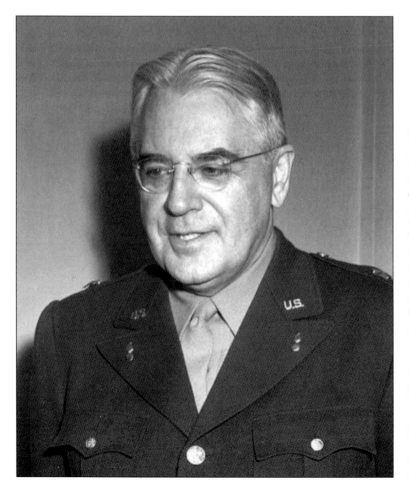

Late in 1942, the U.S. War Department created the Tank Automotive Center to coordinate the army's many vehicle needs. Named to head it was Alfred Glancy, a manufacturing expert who had been a vice president of GM and general manager of Pontiac Motor Division in the 1920s before devoting himself to government service. Glancy was offered an appointment as a colonel but held out for the star of a brigadier general. (GMCMA.)

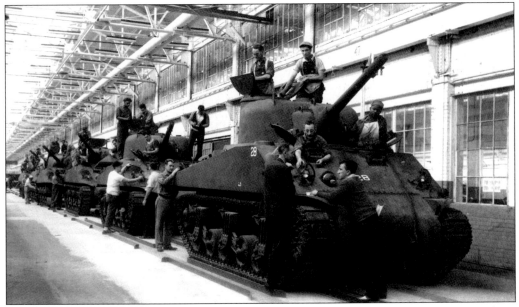

Ford was contracted in June 1942 to mass-produce M4A3 Sherman medium tanks, shown here at the company's Highland Park plant, once home of the Model T and more recently a plant assembling farm tractors. Sherman tanks ranged in weight from 32 to 38 tons, depending on manufacturer, engine, and armor levels. Ford M4s had welded upper hulls and were equipped with the Ford-designed 500-horsepower GAA V-8 engine. (NAHC.)

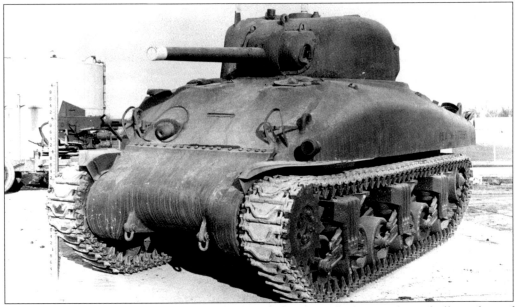

One of the final versions of the M4 Sherman, shown here, had a cast lower hull in place of the earlier, M3-derived riveted differential housing. As the war progressed, 76-millimeter or 105-millimeter cannon replaced the 75-millimeters, "wet" ammunition storage became standard, and a horizontal volute spring suspension (HVSS) system was adopted. Smoother hulls were more protective than angular designs, and cast and welded hulls were stronger than riveted. (TACOM.)

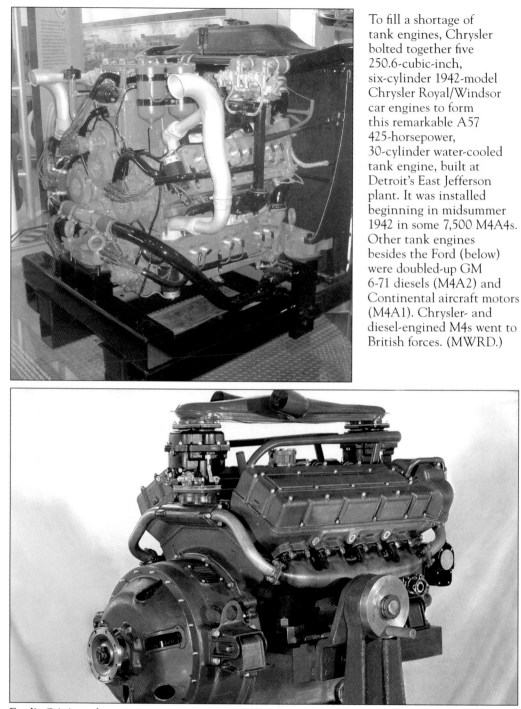

To fill a shortage of tank engines, Chrysler bolted together five 250.6-cubic-inch, six-cylinder 1942-model Chrysler Royal/Windsor car engines to form this remarkable A57 425-horsepower, 30-cylinder water-cooled tank engine, built at Detroit's East Jefferson plant. It was installed beginning in midsummer 1942 in some 7,500 M4A4s. Other tank engines besides the Ford (below) were doubled-up GM 6-71 diesels (M4A2) and Continental aircraft motors (M4A1). Chrysler- and diesel-engined M4s went to British forces. (MWRD.)

Ford's GAA tank engine was a unique 60-degree V-8 overhead-valve, 400- to 500-horsepower, 1,100-cubic-inch design built at the Lincoln plant on Detroit's west side. The design started as Ford's V-12 competitor to the Rolls-Royce Merlin aircraft engine but was converted to a smaller tank engine in 1941. It became the standard engine of nearly 13,000 M4A3 Sherman tanks, the mainstay of the U.S. Army, made by Ford and Fisher Body. (FMCA.)

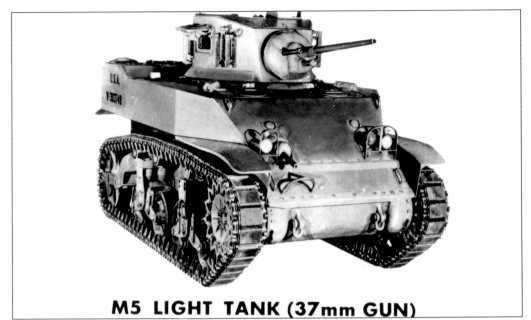

M5 LIGHT TANK (37mm GUN)

GM's Cadillac division built these 16.5-ton M5 Stuart light tanks during World War II. The M5 was a successor to the inadequate prewar M2s and M3s. Cadillac engineers improved performance and reliability greatly by persuading the army to accept twin 1942-model Cadillac 346-cubic-inch, 150-horsepower flat-head V-8s each coupled with a Hydra-Matic automatic transmission, one for each side. Nearly 10,000 M5s were built or converted from M2s and M3s by Cadillac and other manufacturers. (NAHC.)

M8 75mm HOWITZER MOTOR CARRIAGE

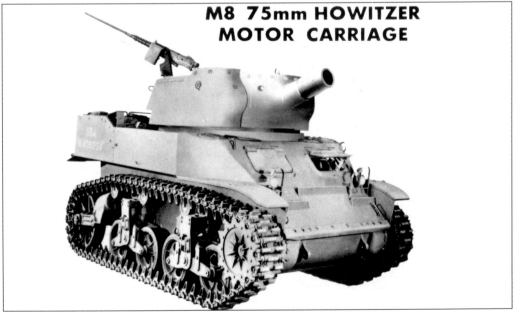

Cadillac also built the 17.3-ton M8 howitzer motor carriage, shown here, an open-turret version of the M5 armed with a 75-millimeter howitzer and a .50-caliber heavy machine gun rather than the M5's 37-millimeter cannon and .30-caliber light machine guns. Some 1,800 were built beginning in the fall of 1942. (NAHC.)

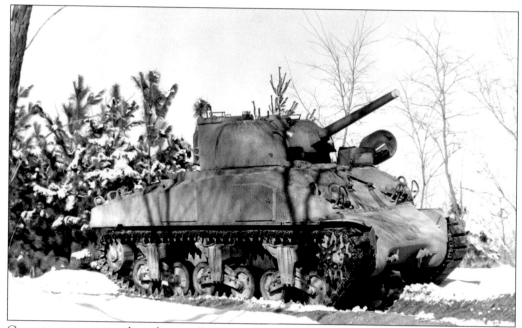

Controversy remains about how well M4s performed against more advanced, heavier German tanks. M4s were fast, maneuverable, and ultimately more reliable and maintainable. M4s with bulldozer scrapers attached became tools for poking through hedgerows and other earthmoving tasks. At worst, Detroit built them faster than the Germans could destroy them. In the Pacific, Japanese island defenders had little to counter them. Late in the war, some M4s were equipped with flamethrowers. (CHC.)

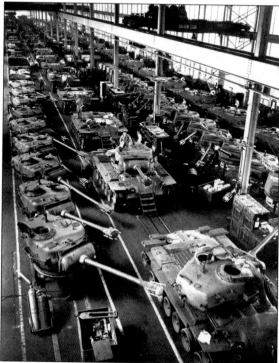

The U.S. Army accepted the M26 Pershing 46-ton heavy tank design in November 1944 to fight Germany's big panzers, but its production came too late in the war to be useful. M26s were produced at the Detroit Arsenal Tank Plant and Fisher Body's Grand Blanc plant, shown here. Powered by a redesign of the Ford GAA, their main advantage was a long-barreled, 90-millimeter gun to counter the German 88. (JS.)

Five

WAR PRODUCTION
OF TRUCKS

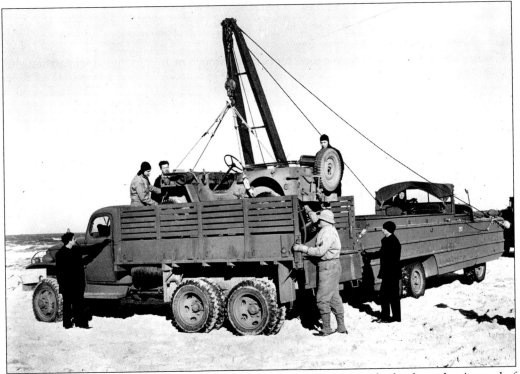

Here in one photograph are World War II's three most important vehicles from the Arsenal of Democracy. None of them are, strictly speaking, fighting vehicles. Each is merely a cargo and personnel carrier. With the aid of a block-and-tackle for lifting, an ever-famous jeep is being lifted between the bed of a GM DUKW "Duck" amphibious truck and the back of a GMC two-and-a-half-ton 6x6 CCKW "Six-By," also known as a "Deuce and a Half" or just "Deuce." The U.S. Army decreed in mid-1942 that the design of each type of vehicle must be standardized and parts interchangeable. (NAHC.)

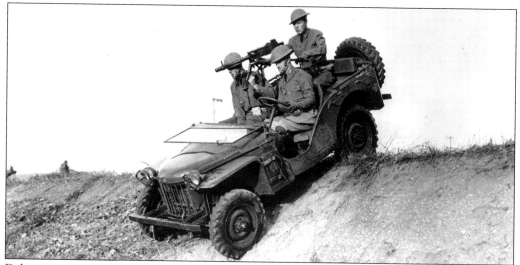

Debate continues among jeep historians, but it seems clear the World War II jeep had its beginnings when the Austin-based Bantam automotive company of Butler, Pennsylvania, approached the U.S. Army with the idea of converting its slow-selling roadster into a light reconnaissance vehicle (LRV). The U.S. Quartermaster Corps visited Bantam on June 19, 1940, and on September 21, a prototype similar to this Bantam was delivered to Fort Holabird, Maryland, for evaluation and testing. (NAHC.)

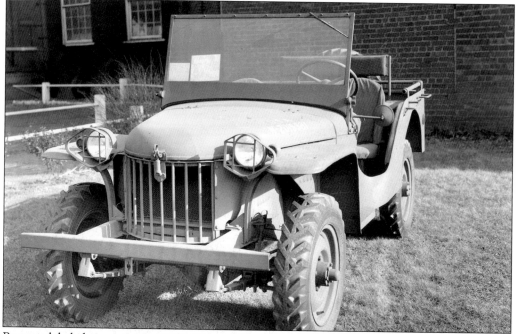

Bantam labeled its prototype BRC (Bantam Reconnaissance Car), referred to as a GPV by the military for "general purpose vehicle." The original prototype model had rounded front fenders. Note the rounded nose front and headlamps scalloped into fenders, somewhat similar to the tiny Bantam passenger cars of the time. Specifications called for four-wheel drive, a 80-inch wheelbase, and a 600-pound load capacity. The army ordered 69 more pilot model BRC-60s from Bantam. (NAHC.)

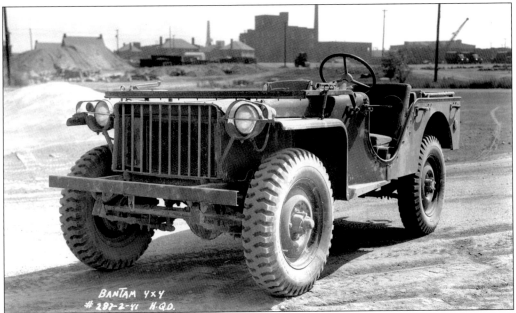

The third and final version of Bantam's effort, early in 1941, was this BRC-40 with flat front end, squared fenders, and brush guard, reflecting designs developed for the U.S. Army by Willys-Overland and Ford, the only two other companies (of 135 solicited) responding to a U.S. Quartermaster Corps July 11, 1940, request for proposals. Approximately 2,675 BRC-40s were built, 62 with four-wheel steering. Most went by Lend-Lease to Britain and Russia. (TACOM.)

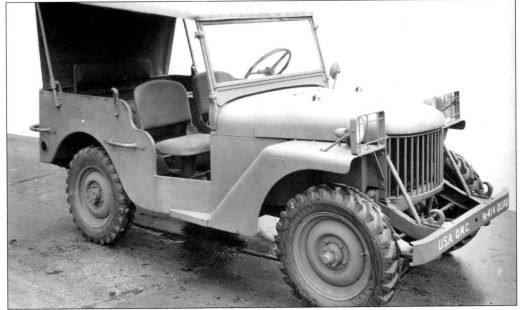

This shows the first Willys-Overland Quad, so dubbed for its four-wheel drive, delivered about November 11, 1940. It closely resembled the Bantam with rounded front end, but headlamps are atop the skirted front fenders. Willys-Overland had been building small four-cylinder passenger cars in a Toledo, Ohio, plant that offered much more production capacity than Bantam. Delivery of prototypes in such a short time by all three companies was remarkable. (NAHC.)

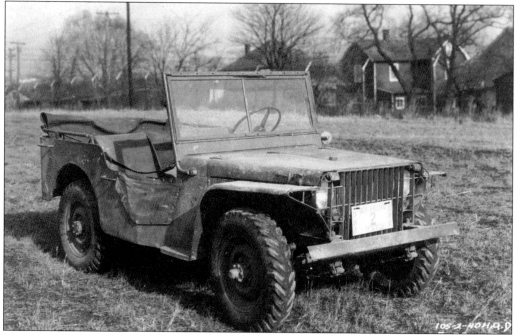

This is the first Ford jeep, originally referred to as the "Pygmy," and by some, "Peep." The date likely was around November 23, 1940, when Ford delivered its initial prototype. The headlamps are within the squared-off front end, behind a welded slat brush guard. Ford's design was the first with a flat front end, adopted by the other two companies the following March. (NAHC.)

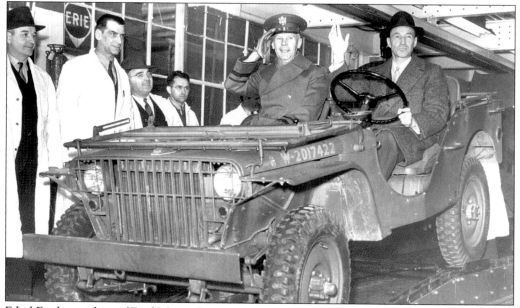

Edsel Ford, president of Ford Motor Company and son of the founder, drove the first pilot model GP, or blitz buggy as it was then called, from a Detroit-area assembly line on February 28, 1941. After initial evaluations of the three companies' prototypes, the U.S. Army awarded them contracts to build 1,500 each for further testing. After testing these, the government decreed a standardized design embracing the best of all three companies' submissions. (FMCA.)

The strength of the Willys prototype was this 48- to 63-horsepower, 134-cubic-inch, four-cylinder Go Devil engine, in production since 1933. Here it is mounted in a GPW, the W standing for the Willys engine in a Ford-built army quarter-ton general purpose truck. Ford's contributions to what became the jeep were its trademark stamped, slotted grille plus some body and chassis features. Bantam provided the original package and concept. (NAHC.)

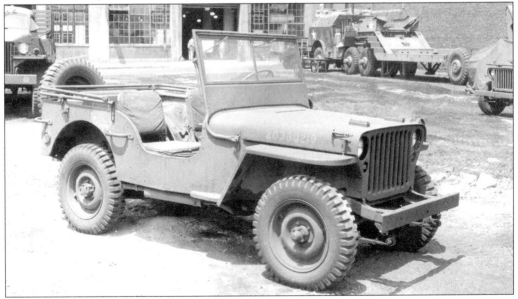

On July 27, 1941, the U.S. Army finally awarded an initial mass-production contract for 16,000 vehicles only to Willys. In reaction to greater demand from military units than expected, shortly before Pearl Harbor, Ford also received a production contract. Early in 1942, the army directed Willys to adopt Ford's cost-saving slotted grille, as seen on this production Ford GPW. (TACOM.)

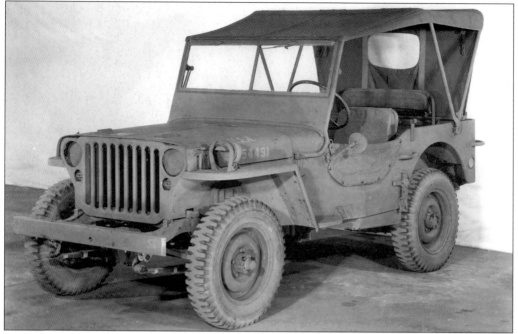

Here is a Willys MB jeep, which is indistinguishable even by keen eyes from a Ford jeep. This engineering reference photograph from the U.S. Army's tank and automotive command (TACOM) shows the Willys with a folding "convertible" canvas top and headlamp covers. Ford had built 282,352 jeeps in six assembly plants when production ended on July 30, 1945, while Willys was credited with 376,397 by its August 20, 1945, end of output. (TACOM.)

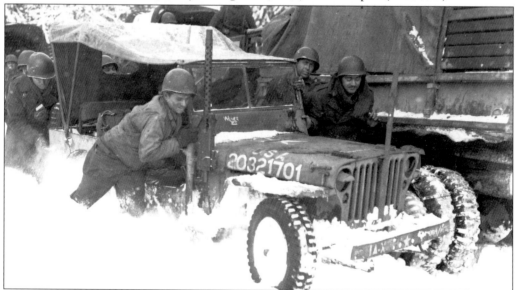

Although the ubiquitous jeep was credited with remarkable performance around the world, it sometimes needed a helping hand under the most adverse of conditions. Here, during the December 1944 Battle of the Bulge along the Belgian-German border, soldiers had to push one through deep drifted snow. Although the photograph came from Willys files in the Chrysler Historical Collection, it could just as well have come from Ford. (CHC.)

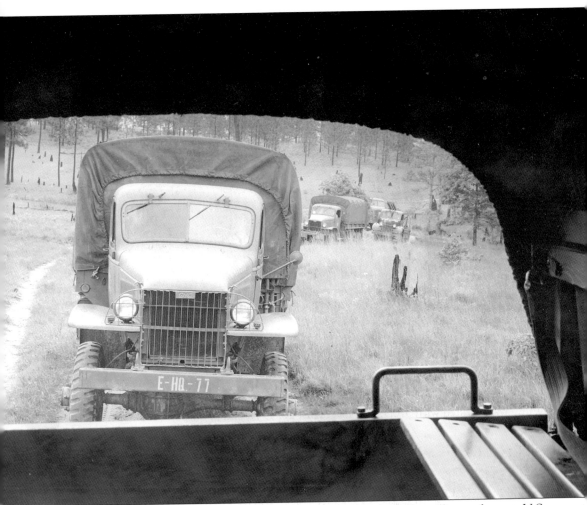

This scene out the rear of a GMC CCKW was one shared by literally millions of young U.S. Army and Air Force men who rode in such trucks over the decades of the 1940s and 1950s. Probably taken during 1941 maneuvers in Louisiana, the photograph shows the GMC badge still mounted on the grille of the following truck. The army did not order manufacturers' trademarks removed from vehicles until 1942. After observing the challenges faced by armies operating a variety of vehicles and long assessments during the years immediately before the war, the U.S. Army decided to standardize on just one two-and-a-half-ton, 6x6 troop and cargo carrier, the GMC. Other two-and-a-half-ton 6x6s were built by Studebaker and Reo, largely for Russia under Lend-Lease. International Harvester 6x6s were built for the U.S. Navy and Marines. In contrast, the German army utilized a wide variety of captured trucks as well as those from different manufacturers within Germany, so consequently faced maintenance nightmares. (NAHC.)

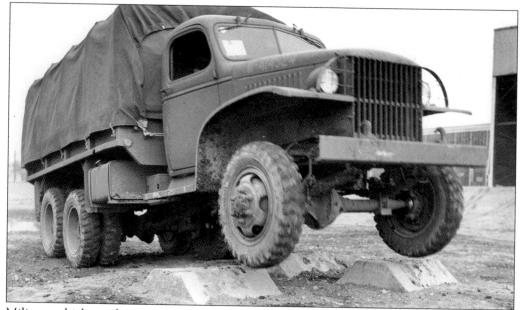

Military vehicles underwent extensive test track and field testing before being ordered for mass production, although time was not always a luxury to be enjoyed when demands for additional vehicles came pouring in as the U.S. Army, enlarged hugely, fought wars across both the Atlantic and Pacific Oceans simultaneously. Feedback from troops operating under harsh conditions, including combat, dictated continual equipment improvements: war's "annual model changes." The army agreed with Detroit producers to limit major upgrades to once a year in order to keep the flow coming from the assembly lines. Still, changes minor and major needed to be proven first, as shown in these views of GMC 6x6 front (above) and rear (below) axle testing. (NAHC.)

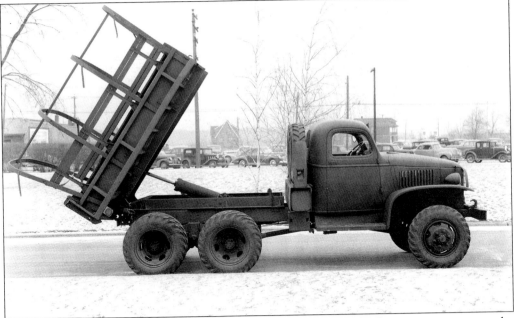

The chassis of the GMC 6x6 could support a variety of bodies. By far the most common was the stake bed with bench seats along the sides and a canvas top fitted overhead, for carrying troops or cargo. Here is a dump-truck version, with the hydraulic piston actuator having raised the bed for emptying. Other bodies included fuel and water tankers. (NAHC.)

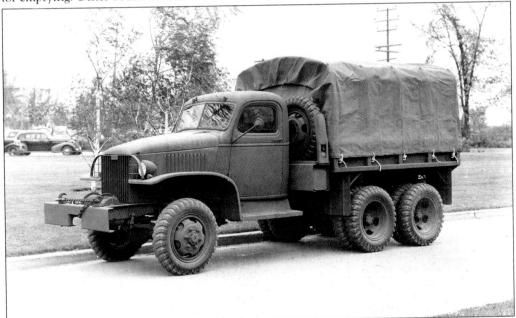

The standard 6x6 at the beginning of the war was this rounded closed-cab version, closely resembling prewar civilian Chevrolet and GMC medium trucks. The 6x6, or six-by-six as it was spoken, meant the truck had three driving axles, vital for providing traction in mud or sand or over rocky terrain. The engine was a 92-horsepower, 270-cubic-inch GMC overhead-valve straight six. (NAHC.)

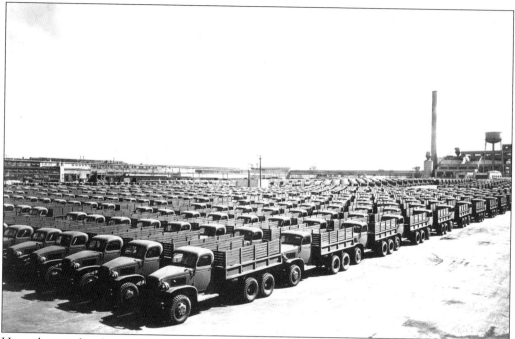

Here thousands of GMC CCKW-model 6x6s are parked at the assembly plant in Pontiac, awaiting shipment to U.S. Army bases or overseas. These are the earlier closed-cab models that went into production in 1941. The CCKW model designation by GMC indicates they were 1941 models with conventional cabs and both front and dual rear-driving axles. (NAHC.)

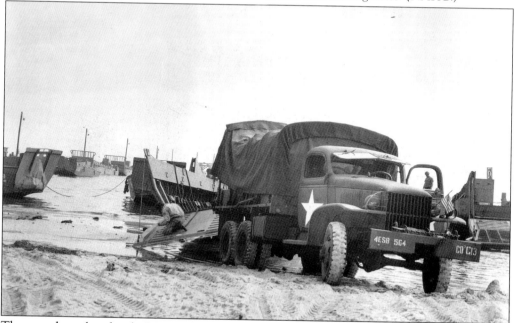

The round, or closed, cab CCKW had a comfort advantage that was unexpected in a military truck, a windshield that opened outward for better ventilation—natural air-conditioning—a feature common in passenger cars up to the late 1930s. Here the 6x6 is being used on a beach to help untangle the ramp from a Landing Craft Tank (LCT). (NAHC.)

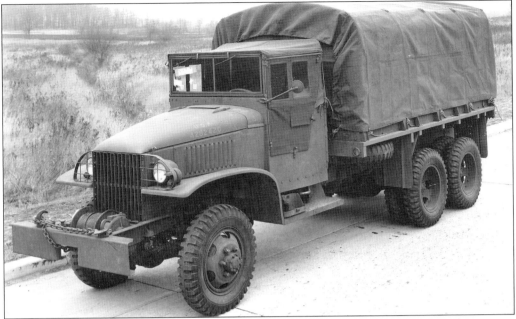

After July 1943, all CCKWs manufactured were "open cab" with canvas top and side curtains and windshields that folded down, presenting a distinctly squared-off appearance. The version shown here also is equipped with a power winch mounted on the front bumper; this feature both extended the overall length and increased the truck's utility. (NAHC.)

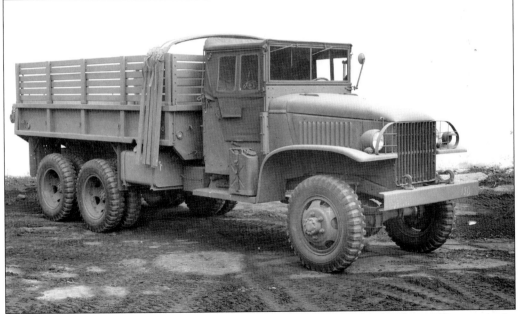

CCKWs were produced in two models: the early-model 145-inch-wheelbase 352, mainly for towing 75-millimeter and 105-millimeter cannon, plus crews, and the 164-inch-wheelbase model 353, shown here, for transporting troops and cargo. The model 352 carried the spare tire vertically behind the cab, but this 353 carried it horizontally under the left front of the bed, so it is not visible in this view. (TACOM.)

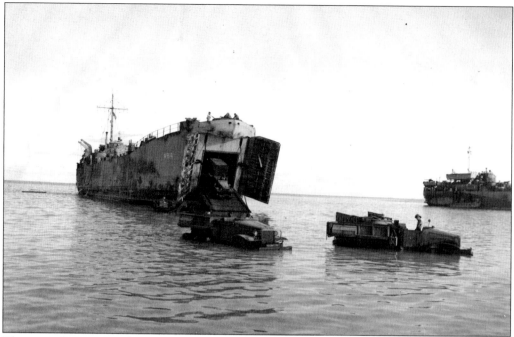

These two late-war-production CCKWs with their cab tops off are shown unloading a Landing Ship Tank (LST) in shallow water, a familiar scene, no doubt, to soldiers in America's island-hopping invasions of the Pacific campaigns of 1944–1945. (NAHC.)

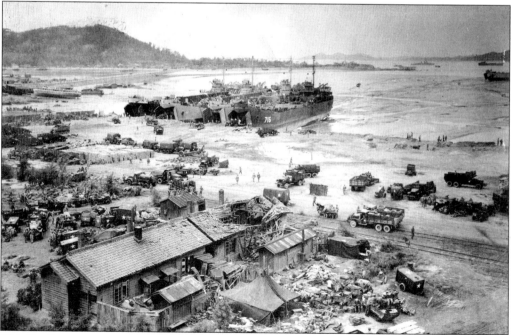

This Pacific war scene, probably at Okinawa in 1945, shows a variety of military vehicles moving supplies forward from LSTs beached to unload. The workhorse CCKW 6x6s are the most numerous. After bombardment from the sea and air, troops had landed and moved inland, but such a "rear area" was never free from aerial or artillery attacks by Japanese forces. (NAHC.)

Long-wheelbase (LWB), open-cab 6x6s are shown in assembly where the cab is fastened to the chassis. The photograph was located in a GMC folder, but correct identity is uncertain because the spare tire is right-mounted like a Studebaker rather than on the left like other GMC LWB models. However, the engine is a GMC. The military may have directed a change in spare tire position. (NAHC.)

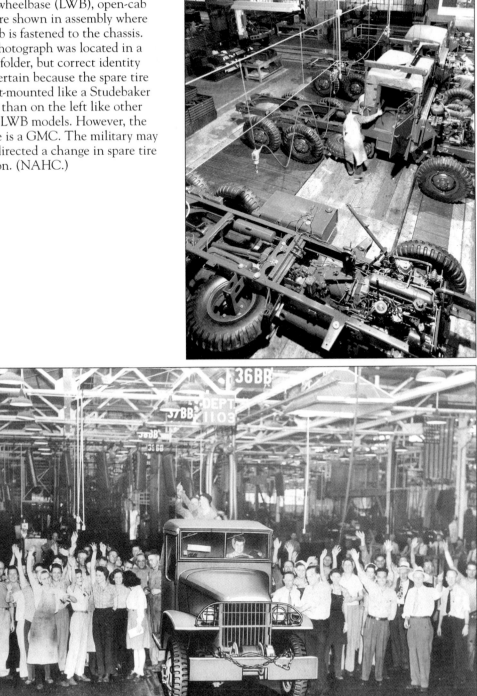

The last GMC CCKW produced for the war is shown here amid employees posing at the division's assembly plant in Pontiac. Altogether GMC built 562,750 CCKW two-and-a-half-ton 6x6s by the summer of 1945. The "Deuces" went on to serve on the United Nations side in the Korean War and were not retired from active duty by the U.S. Army until 1956. (NAHC.)

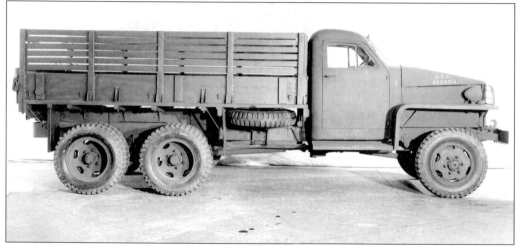

The Studebaker Company of South Bend, Indiana, built 6x6 two-and-a-half-ton U.S. Army trucks like this US6 model in both closed and open cab, and short and long wheelbase versions. The model shown here is a long wheelbase model, with the spare mounted horizontally underneath the right side of the cargo bed. The closed-cab Studebaker has a slightly more slanted hood and windshield than the GMC 6x6. (TACOM.)

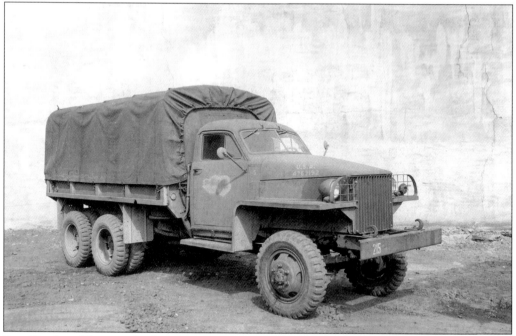

Reo Trucks of Lansing built copies of the Studebaker 6x6 under government contract and license from the South Bend company. This is the Reo long-wheelbase model. Almost all the 200,000 Studebaker and Reo 6x6s manufactured during the war were sent to Russia under Lend-Lease. (TACOM.)

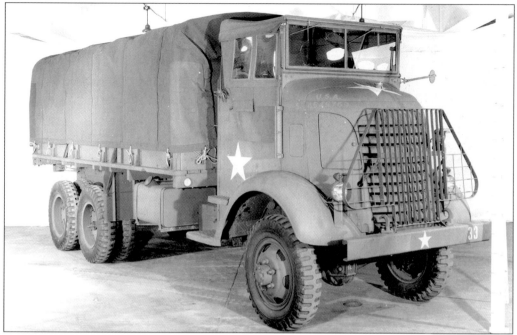

A tall, open-top cab-over-engine (COE) GM AFKWX-353 6x6 is shown in this photograph. Only some 7,000 were built beginning in 1942, sharing many components with the more familiar CCKW 6x6. The advantage of a short, tall cab was greater length of cargo space within the same overall length. This might have been a consideration in shipping tightly packed trucks in ships to go overseas. (TACOM.)

This seven-and-a-half-ton Mack is an example of the relatively rare five-ton and larger heavy-duty 6x6s built for the U.S. Army and Marines. Other military heavy-truck manufacturers included White and Diamond T. Diesel engines also were a rarity among American military vehicles in World War II because they presented fuel supply problems when other vehicles used gasoline. But American vehicles, especially tanks, built for the British army often were diesel powered. (TACOM.)

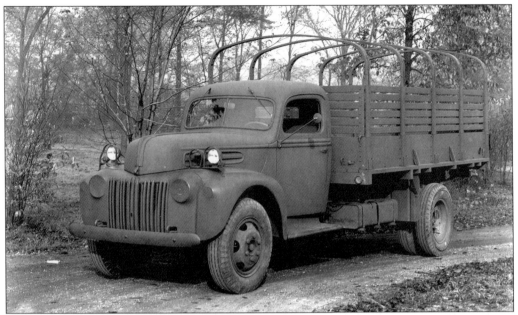

GMC, Studebaker, Reo and other two-and-a-half-ton U.S. Army trucks were not the only military trucks supplied to American and Allied forces. This is a conventional 1942 model Ford 4x2 G8T one-and-a-half-ton truck with military olive drab covering, what might have been either bright trim or light-colored paint on a prewar version. The engine was a 226-cubic-inch, 90-horsepower, flat-head six introduced by Ford in 1941 as an alternative to the V-8. (JKW.)

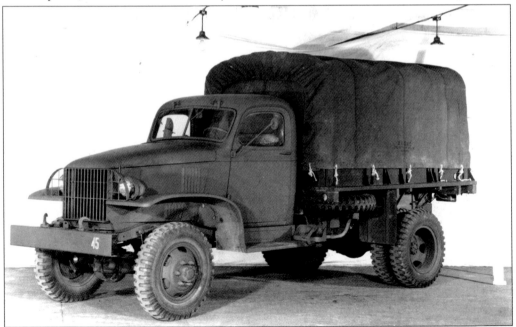

The Chevrolet Division of GM produced a truck for the U.S. Army in World War II similar to the Ford model above. This is a one-and-a-half-ton 4x4 model G506 with a cab very similar to the GMC two-and-a-half-ton 6x6, except it is shorter and has only two driving axles. It was powered by the 235-cubic-inch, 83-horsepower, overhead-valve Chevy six. (TACOM.)

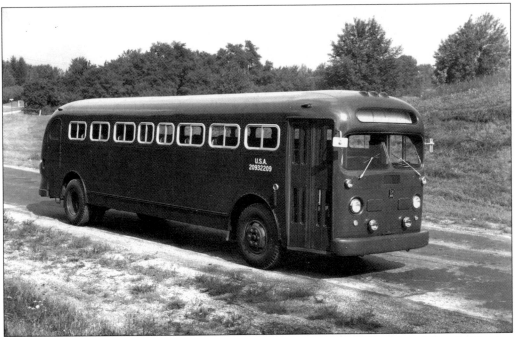

In September 1943, GMC was officially renamed the General Motors Truck and Coach Division (T&C) when the parent company acquired complete ownership of Yellow Coach. This is a Yellow Coach designed and manufactured T-series transit bus modified for military use. It is pictured at GM's Milford Proving Ground in Michigan. Such gasoline-powered buses were widely used to transport military personnel within the continental United States during the war. (NAHC.)

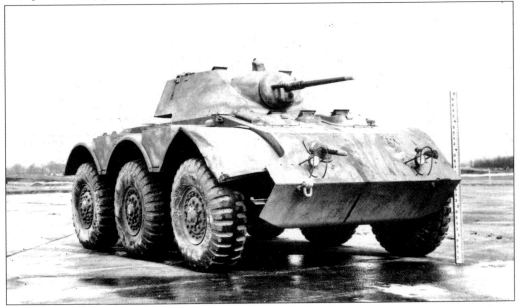

This appears to be a Chevrolet-built experimental T-19 armored car. Armored cars were popular in the World War I period before the development of crawler-treaded tanks. In 1942, the U.S. Army investigated several designs and ultimately settled on the Ford M8, of which 12,500 were built at Ford's St. Paul, Minnesota, assembly plant. They had limited use in World War II. (NAHC.)

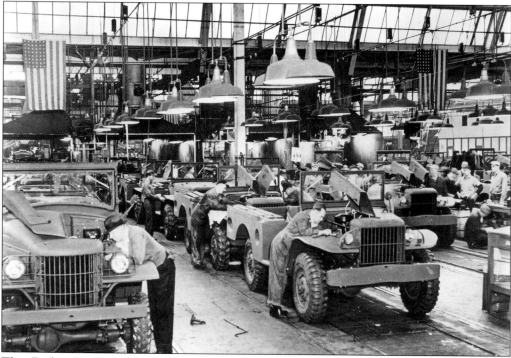

The Dodge Division of Chrysler Corporation became a major supplier of a variety of light-to-medium trucks during the war. In this photograph taken at the Mound Road plant in Warren (not far from the Detroit tank plant) half-ton WC-6 models (left), three-quarter-ton WC-51 weapons carriers, and WC-62 one-and-a-half-ton 6x6 trucks (right) can be seen on parallel assembly lines. The basic designs of the first two produced a variety of applications. (NAHC.)

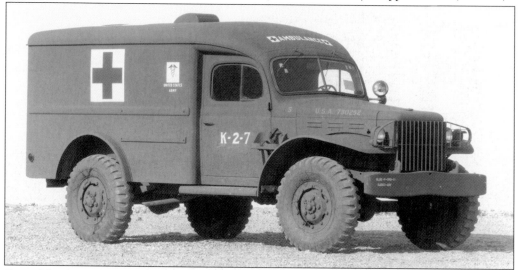

One of the first variations on the Dodge three-quarter-ton chassis was the WC-54 4x4 ambulance with a civilian-type rounded body. It weighed nearly 6,000 pounds. This model replaced an even more civilian-like WC-9 ambulance, of which 2,300 were made in 1941, and was in production until 1944. It was a logical successor to Dodge's World War I ambulance shown on page 13. (TACOM.)

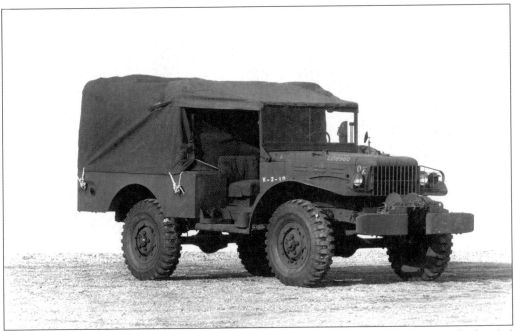

This is a three-quarter-ton 4x4 Dodge WC-52 weapons carrier, which—along with the 6x6 GMC two-and-a-half-ton truck—was one of the war's most recognizable military vehicles. Some 142,000 were produced. WC models came on line late in 1941, replacing the earlier lines of Dodge trucks like those shown on pages 26 and 33. Soldiers called them "weapons carriers," which probably evolved from the WC designation, as the truck was merely a small cargo and troop carrier. (TACOM.)

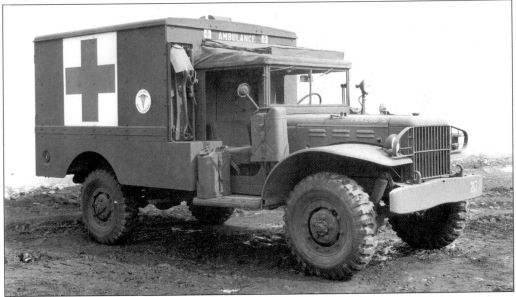

According to some authorities, U.S. Army officials felt utility of the Dodge WC-54 ambulance could be improved by squaring it off and making the side and top panels removable. So this "Knock-Down" WC-64 went into production in 1944. These Dodge ambulances could carry four patients on litters or six seated, plus two medics in front, one driving. (TACOM.)

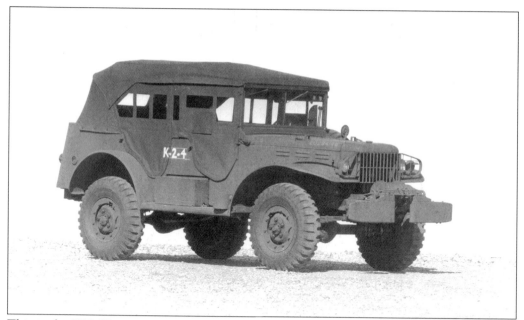

This is the WC-57 command car version of the Dodge three-quarter-ton 4x4 family, with a winch mounted on the front. In between the VC-1 "civilian Power Wagon" version pictured on page 26 and this, there was another, more militarized half-ton WC-7 command car. They carried senior officers of combat units. Dodge built about 24,000 of the WC-56 (without winch) and WC-57s between 1942 and 1945. (TACOM.)

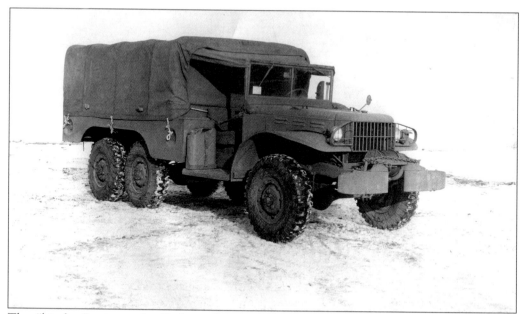

The "big boy" among the Dodge military trucks was this one-and-a-half-ton 6x6 WC-62 personnel carrier. All WCs were powered by a 76-horsepower, 230-cubic-inch truck version of prewar Dodge passenger car flat-head six cylinder engines. The wheelbase was 98 inches on the 4x4 WC versions, longer on the WC-62 to accommodate the third axle length. Dodge built 225,000 military trucks of all types during the war. (TACOM.)

Six

WAR PRODUCTION
OF AMPHIBIANS

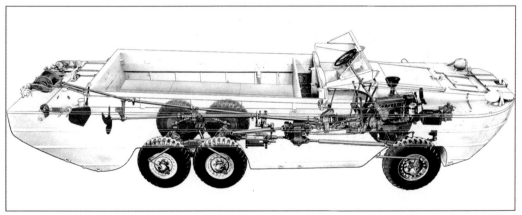

The most amazing of all World War II vehicles was the amphibious truck known as the "Duck," a nickname easily derived from its GM nomenclature of DUKW, in which *D* stood for 1942 model, *U* for amphibious, *K* for front drive, and *W* for two-axle rear drive. It was developed in 1942 by a combination of GM engineers, a marine architect, and U.S. Army officers who realized that, unlike World War I, port facilities would not be available when invading enemy-held lands. This phantom view shows how the medium truck chassis fitted inside the carefully sealed boat hull. (NAHC.)

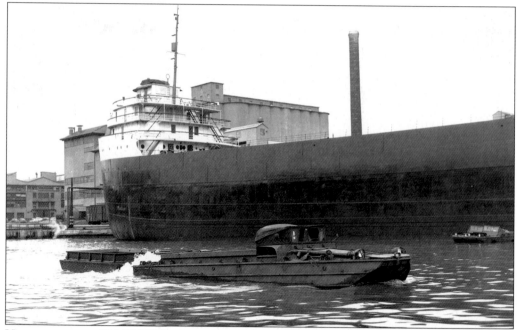

Here a prototype GM DUKW is shown using the Ford Motor Company ship basin at the Rouge plant in Dearborn for testing towing ability in water. In effect, the Arsenal of Democracy became one big automotive company during the war, with normally rival engineers using one another's facilities. As another example, the M4 tank shown on page 47 being tested at the GM Milford Proving Ground was built by Ford. The photograph above, taken in February 1943, shows the GM vehicle sailing past a Ford ore carrier. In the image below, the Duck climbs a ramp out of the ship basin in front of the assembly plant where Ford made jeeps during the war. The ship basin, branching off the Rouge River, can be seen in the middle of the aerial view of the Rouge plant on page 32. (NAHC.)

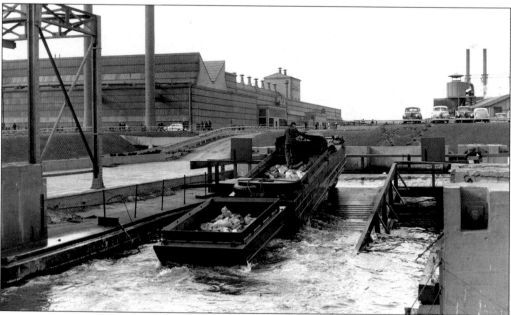

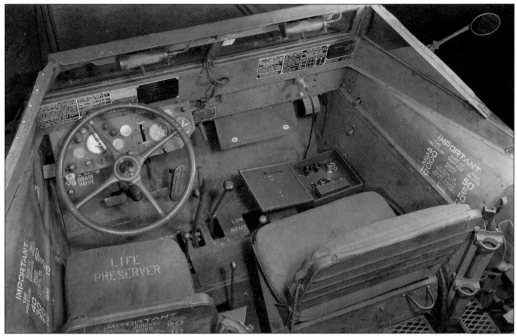

In most respects, the cockpit of the DUKW was not too different from any other medium truck: instruments, clutch, brake and accelerator pedals, steering wheel, parking brake, and gearshift lever. Other levers engaged the six-wheel drives and the propeller. An innovation was that the driver could remotely increase or decrease pressure in all six tires for required traction. (NAHC.)

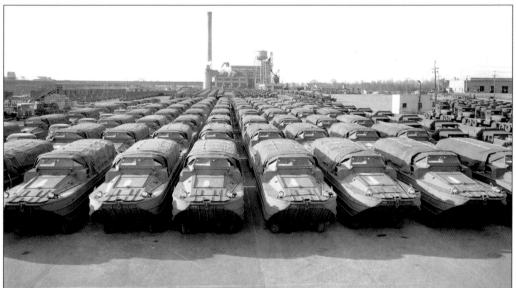

From 1942 to 1945, GM produced more than 21,000 DUKWs. Here a mass of the amphibious trucks, also called hybrids, are parked outside a GM assembly plant awaiting shipment to ports on both U.S. coasts. The U.S. Army and Marines formed DUKW companies for crews, who required special training. Drivers had to learn how best to navigate rough seas and read waves for landing and embarking efficiently and safely. (NAHC.)

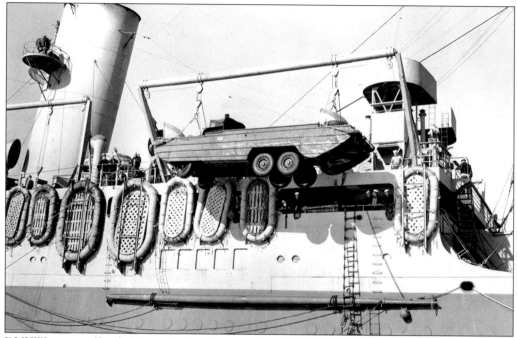

DUKWs were offloaded from decks of cargo ships via hoists, as shown here. Generally the merchantmen stood several miles offshore from landing beaches to avoid shell fire, leaving the Ducks to carry their loads across open water to their designated landing spots. The U.S. Army paid GM $10,800 each for the 31-foot-long hybrid trucks/vessels. (NAHC.)

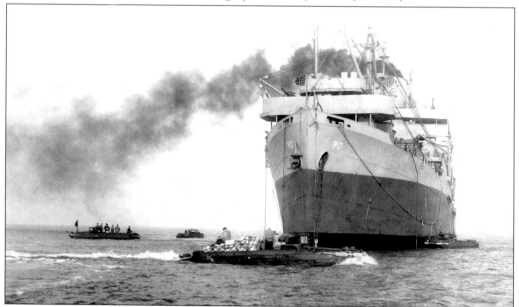

Typically a platoon of Ducks would cruise around the cargo ship awaiting cargo or to form up as a unit for the beach approach. DUKWs were not armored, although some other World War II American amphibians such as Studebaker Weasels and Marine Corps Alligators were shielded. However, in the 1945 invasion of Okinawa, some Marine Corps Duck crewmen began wearing Air Corps flak jackets for protection. (NAHC.)

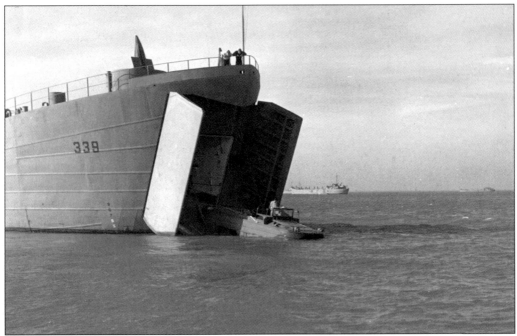

Another way DUKWs could be launched was when they were transported to an invasion location aboard LST vessels, shown here, where they could simply drive off the open bow ramp into the water, provided it was calm enough for the LST's ramp to be opened. LSTs could be beached for offloading but generally held back until enemy counterattacks were unlikely. (NAHC.)

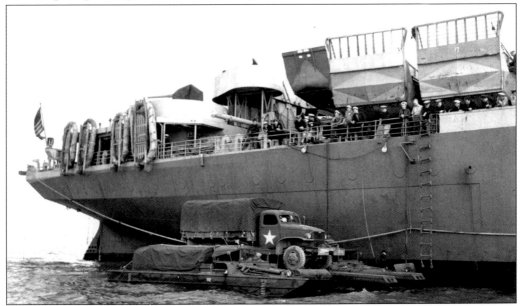

When there is no port to unload a cargo of two-and-a-half-ton trucks, how does one get them ashore to support an invasion? In World War II, ingenious U.S. Army and Marine transporters would lash two DUKWs together with a platform in between and have the ship lower the truck onto the rig. Then it could be sailed to the beach and removed with a block-and-tackle arrangement. (NAHC.)

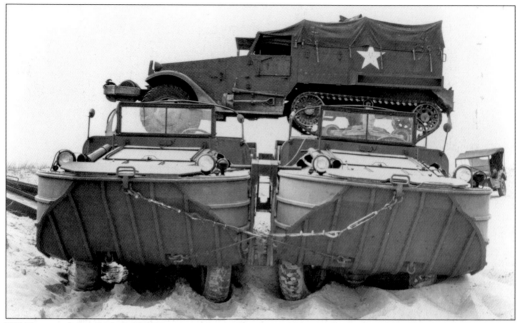

While an unloaded CCKW two-and-a-half-ton truck weighed about 14,500 pounds empty, the White-designed M2/M3 half-track armored personnel carrier weighed two tons more, so carrying one from ship to shore required a different approach for Duck transporters. Here an M2 half-track is carried crossways over two Ducks chained together. International, Autocar, and Diamond T also built half-tracks for the war effort, for a total of more than 20,000. (TACOM.)

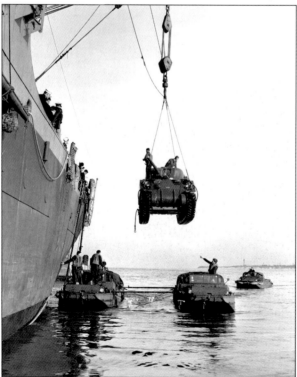

The DUKW solution to transporting an M4 tank from ship to shore was similar to that for dealing with the two-and-a-half-ton CCKW truck, mounting it on a platform between two of the hybrids. In this photograph, a 35-ton M4 is being lowered by derrick from the ship to the two Ducks on the water. (NAHC.)

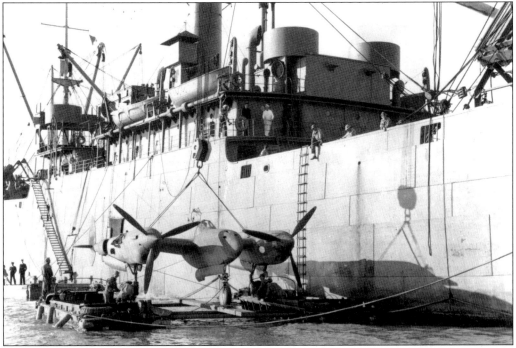

The DUKWs proved far more seaworthy, even in rough seas, than expected and won over skeptics with a fine operational record. They even moved this Lockheed P-38 Lightning fighter across the water, suspended between two units in a rig similar to that for 6x6 trucks and M4 tanks. Although unwieldy looking, a P-38 actually weighed a ton less than a 6x6 truck. (TACOM.)

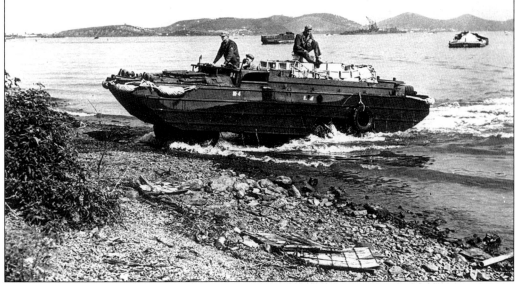

Without hesitating, DUKWs could transition from water to shore easily. Drivers learned to gun the engine as the wheels touched to gain speed climbing the beach gradient. The amphibious trucks could be driven miles inland with their cargoes at speeds up to 50 miles per hour and then return wounded troops from the battlefront quickly to hospital ships lying safely off the coast. (MWRD.)

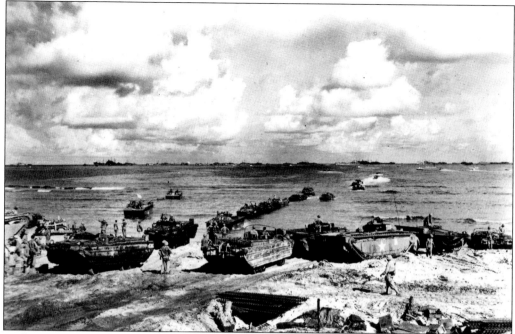

In this Pacific war scene, DUKWs on the left share the beach with Marine Corps LVTs (Landing Vehicle, Tracked) developed in 1940 and built by FMC (Food Machinery Company). The advantage of both vehicles was that they could easily cross the offshore reefs, frequently blocking larger vessels from landing areas of Pacific islands. The LVT could make seven miles per hour on water, faster than a Duck, but at 15 miles per hour was much slower and more unwieldy on land. (NAHC.)

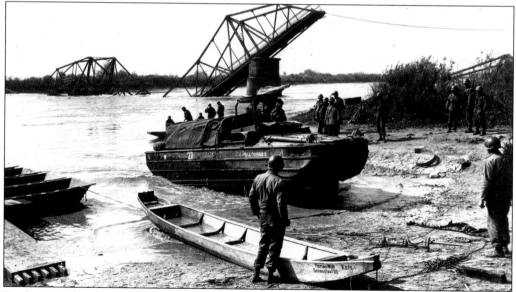

Ducks proved to be extremely useful in the European theater to cross the countless rivers in pursuit of retreating German forces in 1944–1945, as in this 1945 scene in Germany. Most bridges were destroyed by one side or the other. The fresh water of rivers was much kinder to DUKW hulls and running gear than the sea's salt water, which corroded them quickly. (NAHC.)

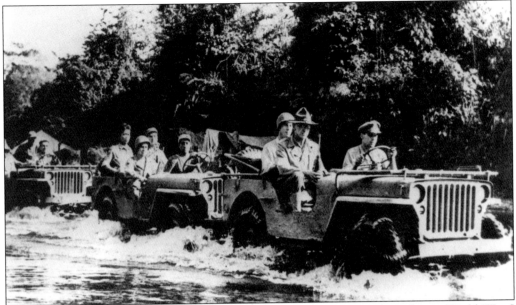

In this wartime photograph, Gen. Joseph W. Stillwell wears his trademark pre–World War I campaign hat while riding in a jeep through a shallow river in Burma. In anticipation of a need for small amphibious vehicles that could handle deeper water, late in 1941 the U.S. Army sought designs from Ford and Marmon-Herrington. The Ford design was selected, resulting in the amphibious GPA, or Seep as it was soon called. (NAHC.)

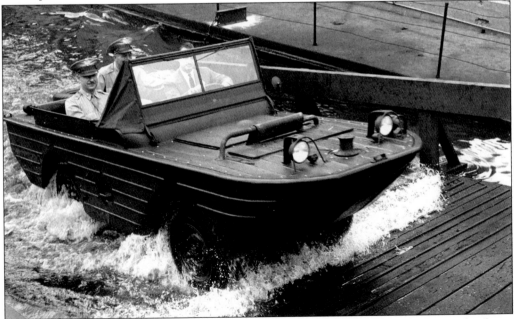

As with evaluation and testing of prototype DUKWs a few months earlier, the Rouge ship basin also was used for 1942 development work on the Ford GPA Seep. Here a prototype is shown being driven up the boat ramp by a civilian with two U.S. Army officers aboard. The Seep followed the Duck approach of a steel hull welded to the frame and chassis of a vehicle beneath, in this case, a GPW jeep. (NAHC.)

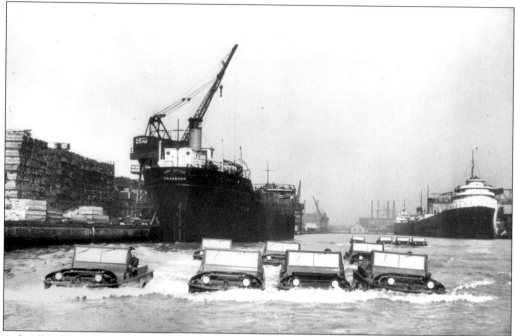

A flotilla of GPA Seeps is shown being tested in the calm inland waters of Ford's ship basin. Ford received initial orders to mass-produce about 13,000 of the small amphibians in 1942–1943, but no more were built because they were found, unlike the larger GMC DUKW, to be unseaworthy and easily swamped in anything but a light chop. (MS.)

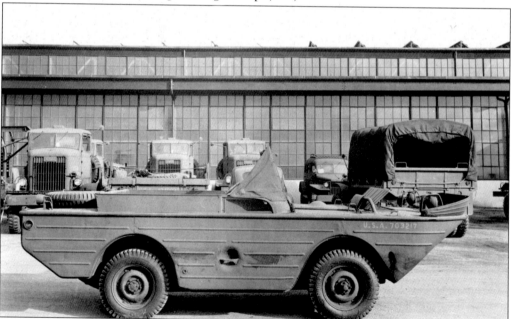

This is a side view of a Seep on land, looking more like a boat than a quarter-ton hybrid truck. The Seep wheelbase was 84 inches, 4 inches longer than the GPW jeep, and overall length was 182 inches. Internal mechanicals were the same as the GPW except for a power takeoff from the 134-cubic-inch engine to turn the propeller. (TACOM.)

Seven

WAR PRODUCTION
OF AIRCRAFT
AND MUNITIONS

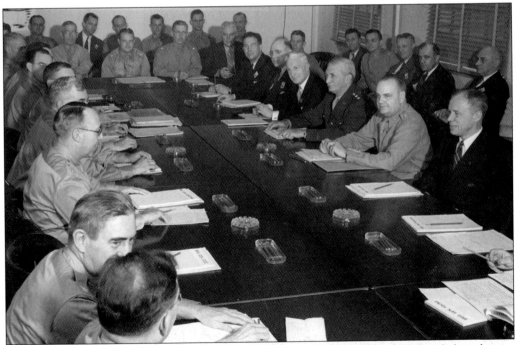

William S. Knudsen's initial Washington appointment in May 1940 was to head the advisory commission on industrial production for the Council on National Defense. In January 1941, that organization was expanded by Franklin D. Roosevelt into the Office of Production Management (OPM), with Knudsen as director general. In this July 3, 1942, scene, Lieutenant General Knudsen (center, right) is chairing a meeting of civilian and U.S. Army officials, including Robert P. Patterson, undersecretary of war (far right). (WSK.)

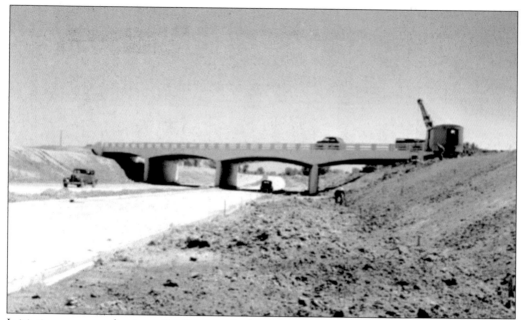

Initiating mass production of military vehicles from existing automotive plants was entirely different from creating a mass production aircraft industry from scratch. Ford's Willow Run plant for B-24 bombers was the largest such effort, and its erection in the middle of a farming area west of Detroit required a whole new infrastructure. A new multilane, limited-access highway system, shown here in final construction phase, was installed around Willow Run. (MDOT.)

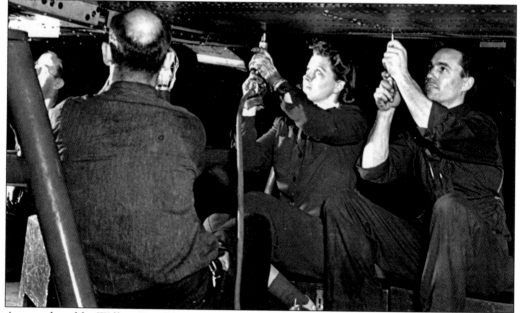

A new plant like Willow Run has no existing labor force. In an already tight labor market, Ford had to screen, hire, and then train tens of thousands of workers, most new to factory jobs. These new Willow Run employees, including women brought into skilled trades and heavy assembly work alongside men for the first time, are being trained to rivet large aluminum panels on a bomber. (FDR.)

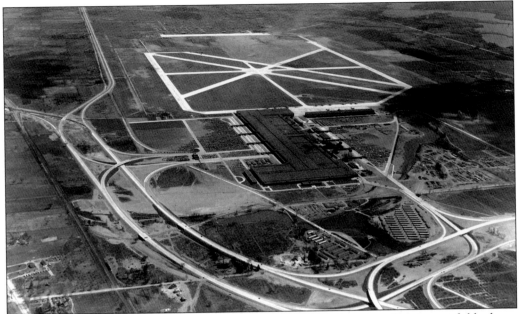

This aerial photograph of the Willow Run complex, including its adjoining airfield, shows how massive the enterprise was. Ford already owned much of the over 1,000 acres needed and acquired the rest quickly. Contractors broke ground in 1941 for the airfield on March 28 and for the factory on April 18. The mammoth facility was about 25 miles west of Ford's Rouge plant. (MS.)

Due to shortages of personnel, tooling, machinery and materials, and other snags, the Willow Run plant became frustratingly slow to get into production. The first B-24 center wing section was completed on April 16, 1942, for shipment to the Consolidated Aircraft plant in Fort Worth, Texas. Ford completed assembly of its first B-24 for Air Corps inspection on May 15, evaluated by Lt. Gen. William S. Knudsen on June 11 when this photograph was taken with Ford officials. (WSK.)

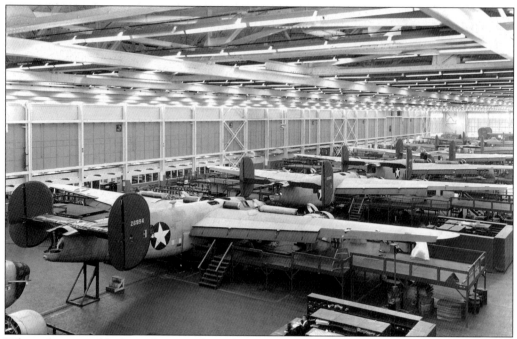

When this assembly line photograph at the Willow Run plant was taken on November 12, 1942, Ford mass production of B-24s was well underway, although still short of goals. The first complete, regular-production Willow Run bomber had been produced on September 10. Consolidated Aircraft initially wanted Ford only to supply components for its own Fort Worth assembly, but Ford insisted on building complete aircraft. (MS.)

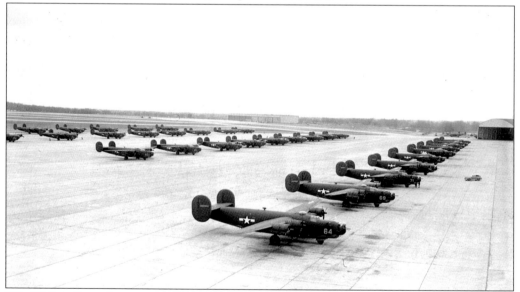

The Willow Run plant manpower reached a daily high of 42,331 in June 1943. Peak monthly production of 462 bombers was achieved in March 1944. Aviation and military officials ridiculed Ford's belief in 1941 that it could produce a B-24 at the rate of one per hour. However, that goal was exceeded in April 1944, with output of 455 planes in 450 hours. This was the miracle of Willow Run. (WPRL.)

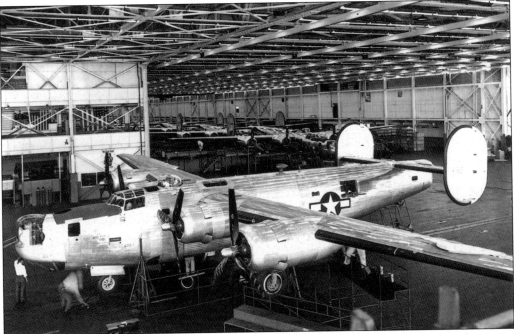

Similar to the Detroit experience with tanks, feedback from the war front brought substantive changes to B-24s. Camouflage paint, which had a weight penalty, was discarded for greater speed and bomb capacity or range, and improved gun turrets were mounted. The Boeing B-17 was considered a better bomber, but B-24s were faster and carried larger bomb loads. Ford mass-produced B-24s very efficiently. (MS.)

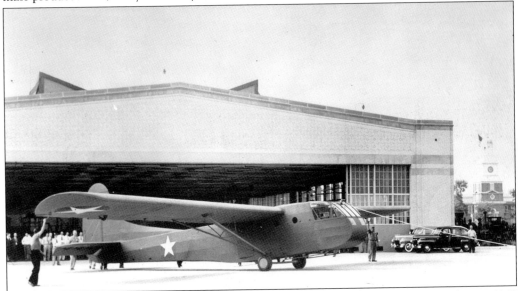

Since German forces had successfully used airborne troops landed by engineless gliders in 1940 and again in 1941, the U.S. Army approached Ford about mass-producing the CG4-A glider designed by Waco Aviation of Troy, Ohio. This is the first Ford-built glider, at the company's Dearborn airport-turned-test-track, on September 16, 1942. The hangar in the background had been built for Ford Tri-Motor aircraft in the 1920s. (NAHC.)

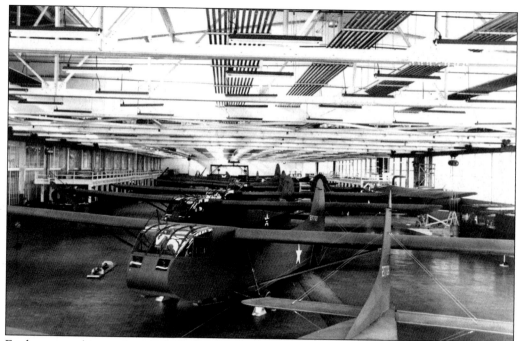

Ford converted its station wagon body plant at Iron Mountain to glider production. This shows the production line for the 15-passenger CG4-A, which had a fabric-covered tubular steel fuselage, plywood wings, and wooden floor. By the end of the war, Ford had built about 4,200 of this glider model. (MRHF.)

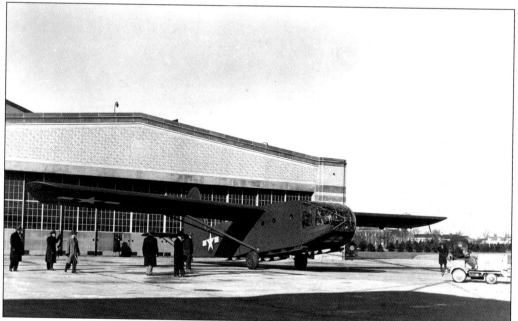

The U.S. Army brought plans to Ford in 1943 for this larger CG13-A, 30-man glider. Ford built only 100 of these before the program was cancelled. The Allies used gliders, along with parachute troops, for airborne attacks in North Africa, Sicily, Italy, Normandy, Holland, and New Guinea. (MS.)

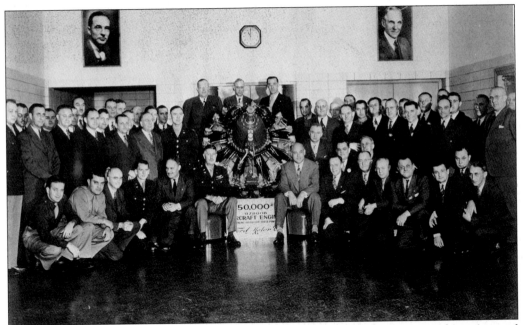

The U.S. Army Air Force continually increased production quotas for the Ford-manufactured Pratt and Whitney R-2800 aircraft engine. To meet these goals, Ford subcontracted work from the new Aircraft Engine Plant at the Rouge (see page 32) to Ford plants around the country. Ford thus became a leading aircraft engine maker, noted when officials pictured here celebrated passing the 50,000 mark. By V-J Day, August 14, 1945, Ford had manufactured 57,851 R-2800 engines. (MS.)

Nash, Packard, Buick, Chevrolet, and, notably, Dodge also became large-scale producers of aircraft engines or their components. The U.S. Air Force engaged Chrysler Corporation in December 1941 to produce 2,200-horsepower Wright Cyclone engines for the forthcoming B-29 Super Fortress bomber. The Dodge-Chicago Division was created, and Albert Kahn designed this monumental Chicago plant to manufacture the engine. (CHC.)

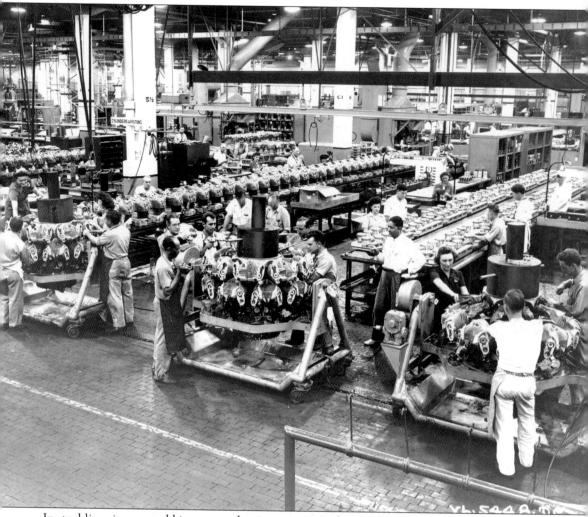

In tackling its second-biggest production contract for war material, the Wright-designed B-29 engine, Chrysler ran into problems it never faced in building and running the Detroit Arsenal Tank Plant. There were shortages of everything as the nation changed from civilian and defense production to urgent war production after Pearl Harbor. Dodge-Chicago could not get the machine tools it needed. Chrysler, akin to Ford's experience with Consolidated Aircraft, discovered the Wright Aeronautical Company had not designed the engine for mass production, and prototypes did not even have interchangeable parts. As the war progressed, labor shortages increased, further complicated by military drafts of eligible males. Endless design changes delayed production. Consequently, main engine assembly in the giant—82 acres under one roof—plant southwest of Chicago did not start until January 1944. Peak employment of 33,245 was reached in 1945. By war's end, the Dodge plant produced 18,413 of the 18-cylinder Wright engines. (CHC.)

Illustrating the cooperative nature of war production, here Air Corpsmen and Chevrolet employees pose with one of the engines GM helped make for the Ford-built B-24. DeSoto and Hudson made separate fuselage sections in Detroit for the Martin B-26C bomber: DeSoto the front and Hudson the rear. These sections, along with Ford-built Pratt and Whitney engines, were shipped to a Martin plant in Omaha for assembly into the aircraft. (GMCMA.)

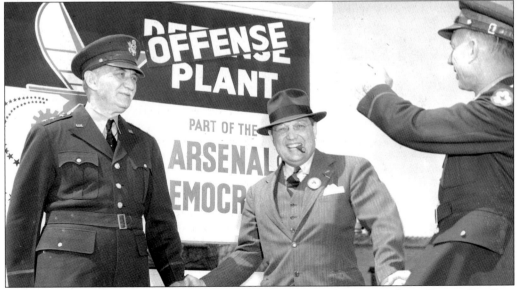

During a May 1942 inspection of the Boeing Aircraft B-17 plant in Wichita, Kansas, Lt. Gen. William S. Knudsen was photographed with a Boeing official and another U.S. Army officer. The sign in the background is notable. "Defense" has become "Offense" at a plant that labels itself "Part of the Arsenal of Democracy." The arsenal slogan stood for far more than just Detroit. (WSK.)

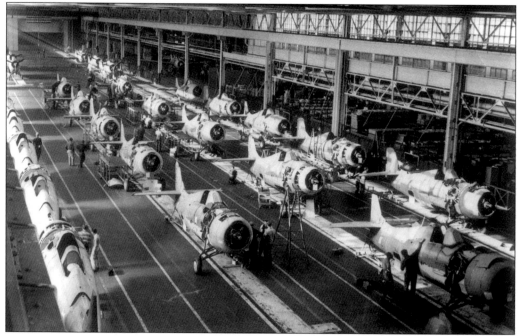

For generations, GM was American industry's colossus. In 1941, GM accounted for 47 percent of new car registrations. With GM's huge manufacturing capacity to support its market position converted to war production, it was hardly unexpected that GM became America's largest defense contractor, as measured in dollars. Among its wartime products were Grumman Wildcat navy fighters, shown here on a GM assembly line in New Jersey. (GMCMA.)

GRUMMAN "WILDCAT"

To manufacture Grumman F4F-4 aircraft like this Wildcat, GM created an Eastern Aircraft Division and utilized the former Buick-Oldsmobile-Pontiac assembly plant in Linden, New Jersey. GM built, under license from Grumman, some 5,000 of World War II's 7,860 Wildcats, designated FM-2s, for U.S. and British fleets. The aircraft carrier and island-based Wildcat was the U.S. Navy's Pacific workhorse fighter until the improved F6-F Hellcat replaced it in 1943. (GMCMA.)

The GM Linden plant also assembled this Grumman TBF Avenger torpedo bomber under license. Relabeled TBM to indicate its GM manufacture, this was the aircraft type flown by 41st U.S. president George H. W. Bush when, as a young U.S. Navy pilot, he was shot down during a bombing mission over a Japanese island in 1944. GM built 7,546 Avengers, more than the Grumman company itself. (GMCMA.)

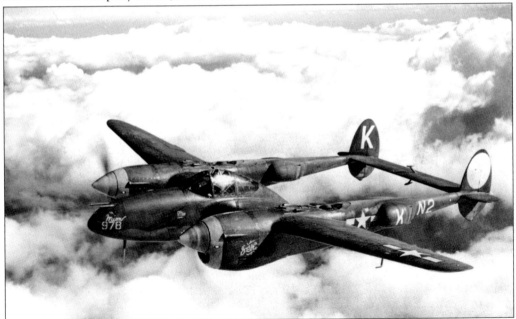

GM invested heavily in various segments in the aircraft industry in the 1930s, including Trans-World and Eastern Airlines, North American Aviation, and the Bendix Corporation. GM's Allison Aircraft Division in Indianapolis made the notable contribution of developing a liquid-cooled V-12 aircraft engine. This distinctive Lockheed P-38 Lightning twin-boom fighter was among many aircraft powered by the Allison V-1710 engine. (GMCMA.)

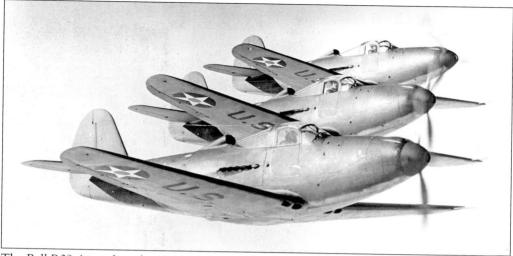

The Bell P-39 Airacobra, shown here, was another Allison-powered World War II fighter plane. The engine was mounted aft of the cockpit, and a complicated driveshaft passed under the pilot to power the nose propeller. The U.S. Navy avoided liquid-cooled aircraft engines like the Allison because it believed radial air-cooled engines could take more punishment without faltering, critical in over-water flying. (GMCMA.)

North American Aircraft's P-51 Mustang, originally powered by the 1,200-horsepower Allison, became the most famous and successful of U.S. Army Air Force fighters. While liquid-cooled engines allowed streamlined fuselage design for higher speeds, the Allison was hampered by supercharger limitations. Consequently, Packard-built Rolls-Royce Merlin engines replaced Allisons in P-51s in 1943. Nevertheless, Allison supplied over 70,000 of its V-1710s for all aircraft during the war. (GMCMA.)

One of the foremost developments among U.S. fighter aircraft during the war was the innovation of "drop tanks." These inexpensive fuel tanks made possible long-range escort of bombers over Europe and could be released when combat was imminent. Here a woman worker at a GM plant is shown with a drop tank in the rust-proofing operation. (GMCMA.)

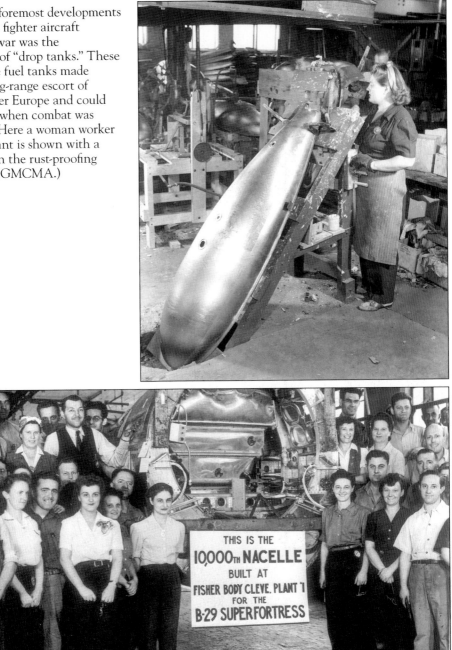

With its dozens of manufacturing plants, the variety of war materials supplied by GM to the war effort seems almost endless. Here GM employees at the Cleveland, Ohio, Fisher Body plant pose proudly with the 10,000th B-29 aircraft engine nacelle (cover) they have built. The B-29 was used for long-range bombing raids on Japan, and one dropped the first atomic bomb that helped end the war in 1945. (GMCMA.)

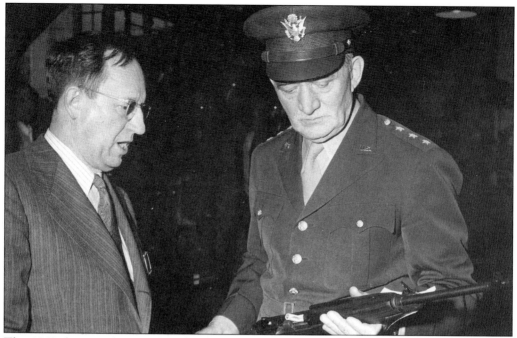

This 1943 photograph of Lt. Gen. William S. Knudsen examining an M-1 carbine manufactured at the Inland Manufacturing Division of GM in Dayton, Ohio, gives another example of the breadth of GM's contributions to war production. In peacetime, Inland made a variety of products, including steering wheels, seat systems, and parts for appliances, diesel engines, motorcycles, and vacuum cleaners. Inland turned out more than three million carbines before the war ended. (WSK.)

GM became one of the largest suppliers of .50-caliber machine guns during the war, producing 1.9 million machine guns and submachine guns altogether. Like other automobile companies, it also provided extensive training in the maintenance of its products, in this case even war products. Here a GM Frigidaire employee and a military instructor conduct a class on the .50-caliber weapon. (GMCMA.)

These Pontiac advertisements proudly illustrate some of the war products of the GM car division, including antiaircraft guns. Sales and marketing personnel of the automotive companies and their suppliers, such as advertising agencies and publications, were devastated by the war because they had no products to sell. The automotive companies helped ad agencies, newspapers, and magazines by producing war-support advertising like this. (GMCMA.)

The most numerous of all materials supplied by GM during the war were artillery shells, shown in this dramatic photograph of a Fisher Body Division inspection. GM manufactured nearly 120 million such munitions, plus another 39 million brass small-caliber cartridge cases. Chrysler Corporation manufactured more than three billion .30- and .45-caliber cartridges at its Evansville, Indiana, Plymouth plant. (GMCMA.)

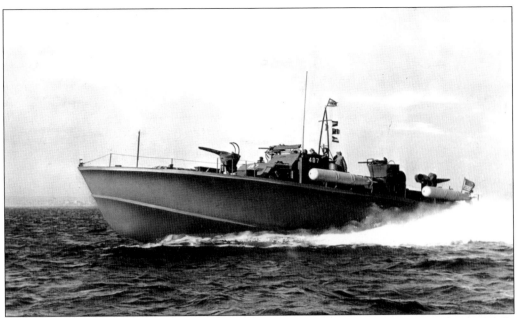

Three marine small-boat manufacturers, Elco, Higgins, and Huckins, built approximately 600 U.S. Navy wooden-hulled PT boats like this one during the war. The 70- to 80-foot-long craft were each powered by three V-12 Packard 4M-2500 liquid-cooled engines derived from the World War I Liberty aircraft engine. Originally rated at 1,000 horsepower, by the end of production, they had been increased to 1,500-horsepower output. (NAHC.)

Easily overlooked in the Arsenal of Democracy's record is the supply of replacement parts for the hundreds of thousands of tanks, trucks, amphibians, aircraft, and munitions produced by the automobile and associated industries. This photograph shows a warehouse full of truck parts destined for shipment to American and Allied military bases. (FDR.)

Eight

THE HOME FRONT

The war's greatest impact at home was that most eligible men were called away to serve in the armed services. This crowd of U.S. Navy recruits is leaving Detroit's Michigan Central railroad station on their way to "boot camp" at the Great Lakes training center north of Chicago. The absence of young men created a huge labor shortage just as the Arsenal of Democracy was in great need of workers. This situation opened the doors of industrial jobs to women and African Americans. (WPRL.)

This *Detroit News* photograph of families jammed into close quarters, in this case 11 persons into just two rooms, typifies the effects of housing shortages around cities where war production created new jobs and new people moved into the communities. The greatest impact occurred where huge new factories were erected. In 1942, the federal government instituted rent price controls to prevent gouging of tenants. (WPRL.)

Families drawn to new plants for wartime employment had to live in whatever housing was available. This tar paper shack was near Van Dyke Avenue and Eleven Mile Road in Warren, north of Detroit. The newly erected tank plant can be seen in the distance. Peak employment of 6,212 at the Detroit Arsenal Tank Plant was reached in 1942. (WPRL.)

The city of Ypsilanti, west of Detroit, experienced terrible housing conditions for new employees at the Ford Willow Run B-24 plant. Run-down camping and travel trailers like these were widely utilized, often parked on soggy ground, and sanitary conditions were awful. The huge number of newcomers swamped the area's housing, schools, and other local government infrastructures, creating resentment of the newcomers in the established communities. (WPRL.)

Amid much criticism from local public officials and in the press, the federal government moved to alleviate the housing shortages resulting from war production. A government agency in Detroit displayed these model homes to demonstrate forthcoming solutions to local housing shortages. (WPRL.)

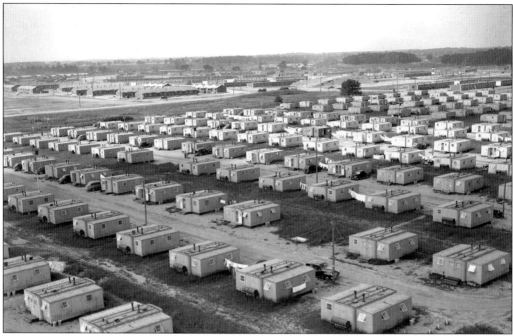

This huge village of government housing was hastily erected near the Willow Run bomber plant. While not attractive or roomy, the two-family units were functional and a big step up from families being crammed together in rented rooms or living in run-down travel trailers. Willow Run employment reached a high of over 42,000 in 1943. (WPRL.)

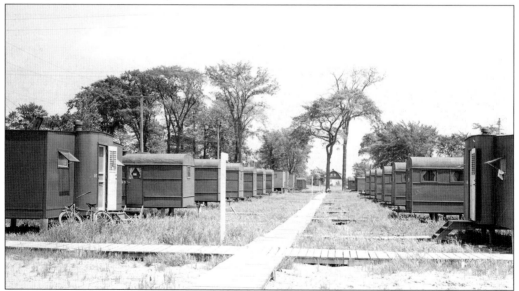

These government trailers, mounted on blocks and connected by boardwalks, were part of the temporary solution to housing shortages and rent gouging in Warren, near the tank plant. Not all newcomers obtained or managed to keep war plant employment. Some replaced local farmers who were better qualified for such jobs. Temporary housing for farm-replacement labor was situated for a time at Selfridge Army Airbase in the northeast corner of Michigan's Macomb County. (WPRL.)

This government housing project, called Sojourner Truth, was planned before World War II for a Detroit neighborhood several miles northeast of the downtown business district. It was designated as new housing for African Americans who were otherwise segregated into the "Paradise Valley" ghetto near downtown. (WPRL.)

When housing shortages became acute as defense and war production increased, racial tensions between blacks and whites—already heightened because of competition for new jobs—arose over the location of the Sojourner Truth project in what had previously been a largely white area. On February 27, 1942, a riot broke out between the two factions. Over 30 persons were injured, and police made 108 arrests. (WPRL.)

Sixteen months later, over two sweltering days in June 1943 and fed by rumors, a severe race riot broke out on Detroit's lower east side near several war plants and the Belle Isle bridge. The next day, rioting spread to the west along Woodward Avenue, Detroit's main north–south artery, where a *Detroit News* photographer caught this sequence. In the photograph above, crowds of men rush across the street, and a car is seen overturned in the right foreground; smoke erupts among traffic in the distance from another overturned automobile that has been set afire. Within minutes, a huge blaze (below) threatens two streetcars that have pulled up in the meantime. The crowd has disappeared, perhaps chased away by police, and motorists are steering around the blaze. This riot resulted in 34 dead, 675 injured, 1,893 arrests, and a terrible reputation for Detroit. (WPRL.)

The home front in Detroit also had its Nazi spy. This is Max Stephan, a German immigrant and naturalized American citizen, who was an east side Detroit restaurateur. In April 1942, he sheltered a German Luftwaffe pilot who had escaped from a Canadian prisoner of war camp. After the pilot was recaptured in Texas, Stephan was arrested, charged with treason, convicted, and sentenced to death by hanging. (WPRL.)

The recaptured Luftwaffe pilot, in his full German uniform, was brought to Detroit to testify against Stephan. Pres. Franklin D. Roosevelt later commuted Stephan's sentence to life imprisonment. Stephan succumbed to cancer in prison 10 years later at the age of 59. The FBI found that Detroit was a hotbed of prewar Nazi activity, but there were never any credible reports of spying or sabotage during the war. (WPRL.)

The Japanese invasion of Southeast Asia early in 1942 cut off supplies of natural rubber and made manufacture of new tires and other essential rubber goods impossible. Scrap rubber recycling drives were launched, supposedly to avoid gas rationing, as the signs here show. It was many months before the American rubber industry could build new plants to produce synthetic rubber. (WPRL.)

A nationwide wartime speed limit of 35 miles per hour was imposed on September 26, 1942, because of the belief that driving slower prolonged tire life. This shows a wartime 35-miles-per-hour speed limit sign near the Pentagon in northern Virginia. Gasoline rationing came next, ostensibly to save tire wear but actually because German submarines had created a fuel shortage by sinking dozens of oil tankers (a well-kept wartime secret) along the Atlantic coast. (NARA.)

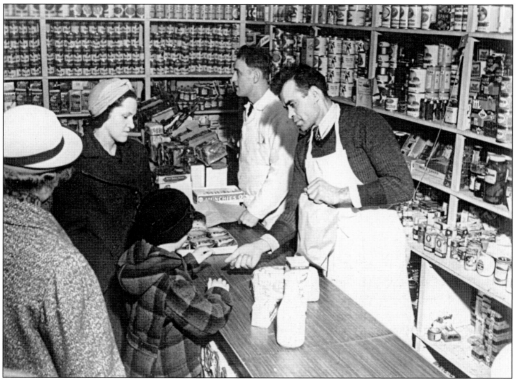

The ration booklet shows:

IMPORTANT INSTRUCTIONS

1. Coupons can be used only in connection with the vehicle described on the front cover. Detached coupons are VOID.

2. If you stop using your car, this book and all unused coupons must be surrendered to your Board within 5 days.

3. If you sell your car, this book and all unused coupons must be surrendered to your Board. The purchaser will not be issued a gasoline ration unless he presents the receipt which you receive at the time of such surrender.

☆ opo

A **BASIC MILEAGE RATION**

UNITED STATES OF AMERICA
OFFICE OF PRICE ADMINISTRATION

NAME OF REGISTERED OWNER
Joseph Huff Dobson
ADDRESS—NUMBER AND STREET
3203 Frisby Street
CITY AND STATE
Baltimore 18 Md.
LICENSE No. AND STATE YEAR MODEL AND MAKE
76-013 Md. 1941 Studebaker

Holder must fill in any blank spaces above before the first purchase of gasoline.

OPA Form R-525 C MILEAGE A17 414703 76-013 M. (License No.) (State)

The Office of Price Administration (OPA) imposed gasoline rationing for civilian vehicles in January 1943, beginning on the East Coast, which was farthest from Gulf Coast fuel sources. All motorists were issued A cards for four gallons per week, others B cards for eight gallons if needed for work, and C cards for driving necessary for the war effort. Motorists had to use coupons like these to buy gasoline. (MWRD.)

Self-service supermarkets were rare in 1942. Most grocery stores had clerks who selected desired items from behind a counter like this one. UPC bar codes, electronic readers, electronic cash registers, and credit cards were decades in the future. Nevertheless, homemakers had to learn a whole new way of shopping when food rationing was imposed by wartime restrictions. (FDR.)

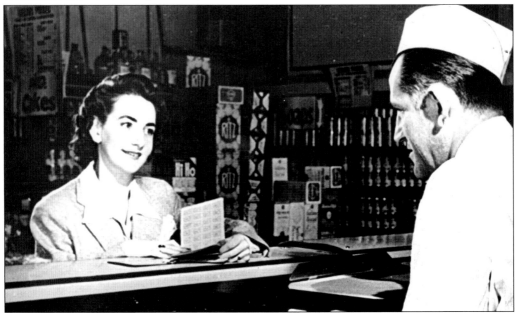

The OPA administered both price controls and rationing during and for a time after World War II. The federal agency issued ration books with coupons like these for gasoline, fuel oil, many foods, and certain kinds of clothing. The OPA had to grant permission for purchase of tires—or even the rare 1942 automobile still in dealer storage—for individuals whose work was essential to the war effort. (MWRD.)

Food rationing was instituted in the spring of 1942, affecting all Americans in their everyday lives. For most of the public, it was their first experience with previously distant federal "alphabet agencies" during New Deal recovery efforts from the Great Depression. This homemaker must exchange a ration coupon and cash to buy meat. (FDR.)

Buying rationed foods became a complicated mixture of money and coupons. Coupon values changed according to war needs and product availability. Rare items required more coupons. These Girl Scouts are learning to juggle shopping lists between coupons and the family food budget. Labels showed both the price and ration points required for purchase. (FDR.)

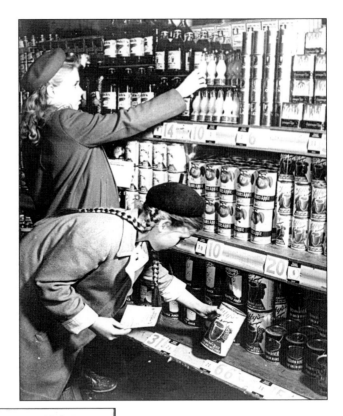

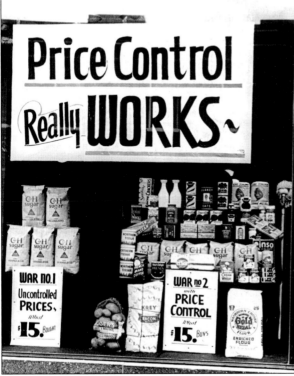

Wartime price controls were established by the OPA to discourage hoarding and prevent runaway price inflation of items in short supply. U.S. troops and those of U.S. allies took priority for all goods. Government controls were supported by coordinated public information campaigns, typified by this sign promoting price ceilings. (FDR.)

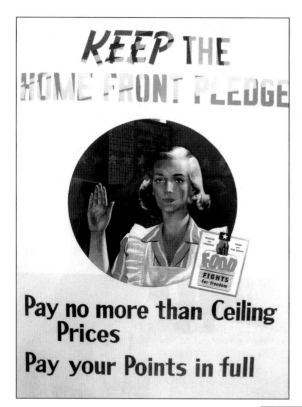

Pay no more than Ceiling Prices

Pay your Points in full

The government encouraged the public with posters like these, produced by various agencies and widely distributed for display in public places. Some posters pushed specific programs, such as complying with price controls and rationing. Wartime posters scolded the few Americans who put self-interest before winning the war and engaged in black market activities, undercutting rationing and price ceilings for personal financial gain. Other citizens opposed government controls for philosophical reasons and needed appeals to patriotism to comply. Posters promoted specific wartime priorities: price controls and rationing, buying war bonds, collecting scrap materials, or advertising for skilled workers. Posters warned against rumor mongering or revealing military secrets, promoted various volunteer activities, and boosted public morale during the long war. (MWRD.)

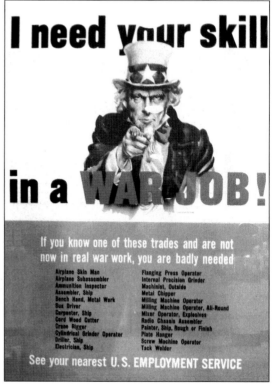

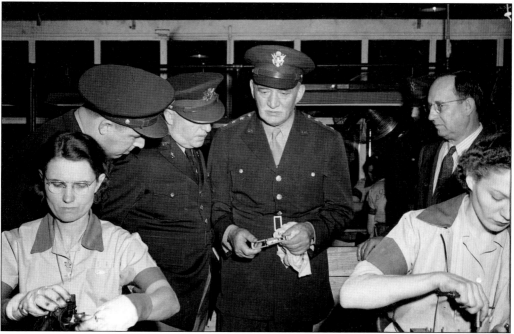

Lt. Gen. William S. Knudsen and other officers in full uniform are shown inspecting small parts at an Ohio war production plant. Knudsen carried the prestige of a high government official, a high-ranking U.S. Army officer, and a former president of GM who knew his way around manufacturing plants. Such person-to-person contact lifted the spirits of war workers. (WSK.)

Washington officials felt it was important to enlist citizens in war support efforts for both morale and practical reasons. The drive to collect scrap metal was a practical need, not only to fill war production requirements but because Axis invasions and submarine warfare cut U.S. supplies of raw materials. Scrap yards like this one in Detroit were harvested for vital metals that could be recycled. (FDR.)

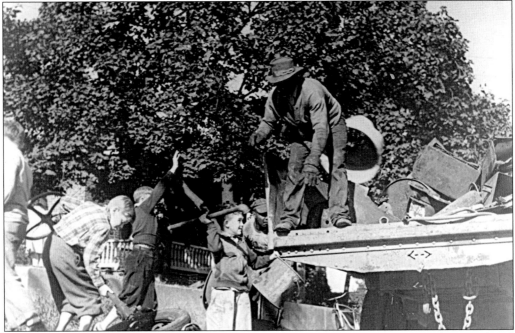

To give children a feeling they were also contributing to the war effort, scrap drives enlisted youngsters to collect metals of all types. Here boys are helping load a truck with cast-off metal items. As an 11-year-old, the author was forced to make a choice between two souvenir World War I brass cannon shell casings he treasured; one had to be donated to the scrap drive. (FDR.)

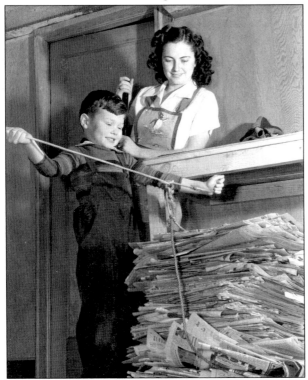

Americans in many communities across the country today are encouraged or required to separate newspapers and other items for recycling to relieve municipal budgets of waste collection costs and to help the environment. During World War II, there were massive drives to collect used paper for recycling to help the war effort. Youngsters happily assisted in these campaigns. (FDR.)

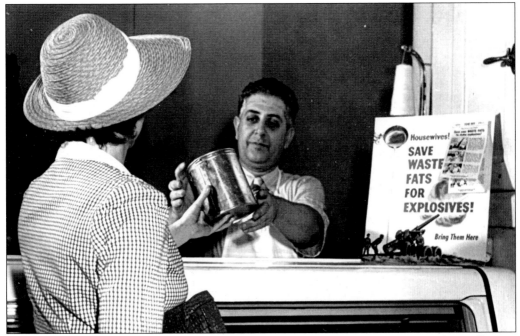

Homemakers were encouraged to save cooking fats and take them to meat market collecting stations for ultimate use in manufacturing explosives for the war effort. Here a woman hands over a tin of fat to her butcher, in a government publicity photograph shot carefully staged to also show the poster on the counter. All Americans were encouraged to do their part toward achieving victory. (FDR.)

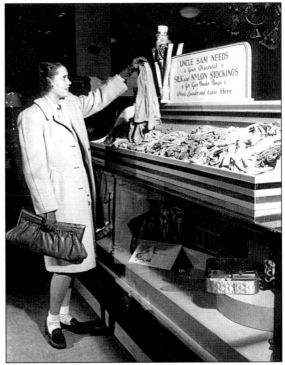

Wartime rationing included many clothing items, especially shoes and women's stockings. Women were also encouraged to donate their unwearable silks and nylons to drives for scrap material. The sign reads, "Uncle Sam needs your discarded silk and nylon stockings for gun powder bags. Please launder and leave here." (FDR.)

The most serious civilian wartime collection was that of blood to treat wounded military personnel. This volunteer is having his blood drawn at a Detroit hospital. The American Red Cross commended the author's mother, a U.S. Army nurse in France in World War I, for being one of her county's most prolific blood donors during World War II. (WPRL.)

The drive to sell war bonds was the most intensive of all the government campaigns directed at Americans during World War II. The initial bond drive, illustrated here, began before the United States formally declared war, and the financial instruments were called defense bonds rather than the later war bonds. (FDR.)

Hollywood stars and war heroes were utilized to mount huge war bond sales rallies like this one. The program encouraged children to save their allowances or odd-job earnings by buying war bond stamps to paste into a book; when $18.75 had been collected, the book could be traded for a $25 bond. The government's overall bond drive aimed at cooling the economy by curtailing spending as well as financing war expenses. (WPRL.)

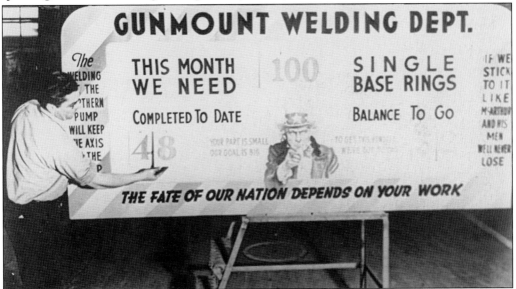

Local plant-level promotions encouraged meeting Arsenal of Democracy production goals. At a Northern Pump Company plant in Wisconsin, civilian parts output was augmented by contracts for gun mounts. This photograph shows a supervisor updating a monthly production progress sign. Uncle Sam says, "Your part is small, our goal is big, to get this hundred we've got to dig." (FDR.)

In a lunchroom meeting at a Philco plant in Philadelphia on August 6, 1942, Lt. Gen. William S. Knudsen exhorted supervisors to rise above U.S. Army goals for communications and radar equipment. The military needed new inventions as well as top quality and huge quantities produced. Philco was a major defense contractor in World War II and the cold war. (WSK.)

Knudsen made a practice of talking to the skilled tradesmen and line workers at every plant he visited. He could communicate easily with people on the shop floor because he had worked as a mechanic and machinist long before he became an automobile industry mass production expert and top executive. Here he converses with a Philco worker after addressing company supervisors more formally. (WSK.)

Victory gardens were encouraged throughout America to provide fresh vegetables in place of rationed canned goods and simply to provide more food when tens of thousands of agricultural workers had either entered the U.S. armed forces or were newly employed in war production. Such gardens were laid out in yards or in community gardens, like this one. (WPRL.)

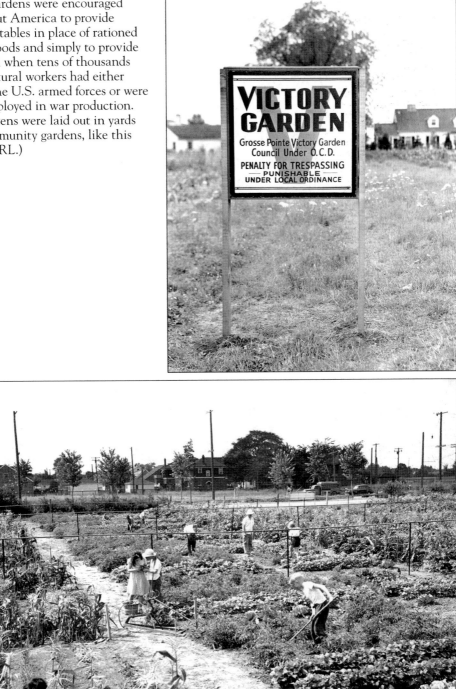

World War II's victory gardens actually were nothing new. Such urban and suburban vegetable garden plots were called liberty gardens in World War I and thrift gardens, like this one, during the Depression. The author recalls harvesting delicious fresh Bibb lettuce and beefsteak tomatoes from his family's victory garden in the backyard of their Louisville home. (WPRL.)

A new type of postal service called V-mail was developed during the war for correspondence with soldiers overseas. V-mail letters were one-page forms that were photographed, reduced in size, put on microfilm for easy shipment, and then at the overseas destination printed out enlarged (left), to be placed in a small envelope (right) for regular delivery. This process speeded mail delivery and drastically reduced the volume of mail taking up scarce space on cargo ships. (MWRD.)

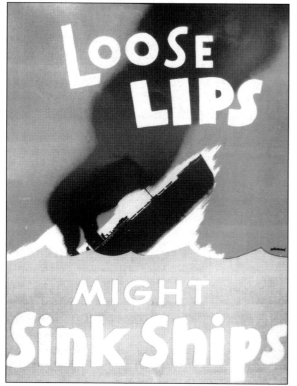

One of the most memorable of World War II slogans and posters was Loose Lips Sink Ships, a warning against carelessly revealing secret or restricted information such as troop movements or sailing schedules. This version of the poster has been softened slightly to "might sink ships." There was great concern about spies but little evidence they actively functioned in the United States. (MWRD.)

Nine

VICTORY

From the very first day of America's involvement in World War II, there was great confidence that the country's side would prevail. Long before victory was clearly in sight, in 1943, this Ford Motor Company full-page color magazine advertisement expresses the sense of a life after the war. The slogan "There's a Ford in your future" became the theme of Ford advertising for several years. Most World War II automotive advertising stressed the war products their plants were making, but late in the war, the advertisements began recalling the last civilian models produced early in 1942. (FMCA.)

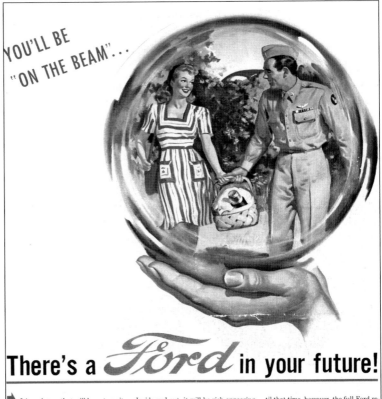

YOU'LL BE "ON THE BEAM"...

There's a *Ford* in your future!

▶ It's a picture that will have to wait.
America has an important job to do before your smart, peacetime Ford can be produced.
. . . But when your new Ford does arrive, you'll be proud of it. For it will be big and roomy—have plenty of "go". Its styling will be youthful, beautiful.

Inside and out, it will be rich appearing —with many refinements. Naturally, it will be thrifty and reliable—as all Ford cars have been for more than 40 years.
. . . Yes, exciting new fun is in the offing for you. For some day the necessary word will come through. And we'll be ready to start our production plans. Un-

til that time, however, the full Ford resources will continue to be devoted to the needs of final Victory.

FORD MOTOR COMPANY

"THE FORD SHOW". Brilliant singing stars, orchestra and chorus. Every Sunday, NBC network. 2:00 P.M., E.W.T., 1:00 P.M., C.W.T., 12:00 M., M.W.T., 11:00 A.M., P.W.T.

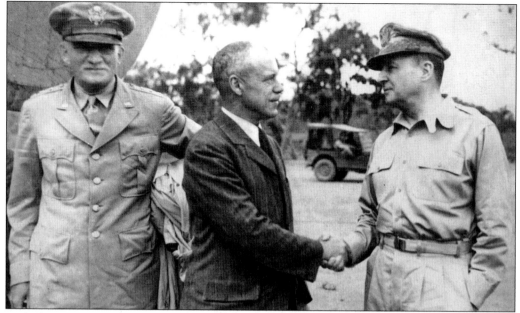

In the later years of the war, Lt. Gen. William S. Knudsen's role in war production concentrated on the aircraft industry when he headed the Air Force Technical Service Division at Wright-Patterson Field in Dayton. In November 1943, at the age of 64, Knudsen and Undersecretary of War Robert P. Patterson made the long trip to tropical New Guinea to confer with Gen. Douglas MacArthur. Knudsen's fatigue from the long trip in propeller-driven airplanes from the United States is evident in this photograph. (WSK.)

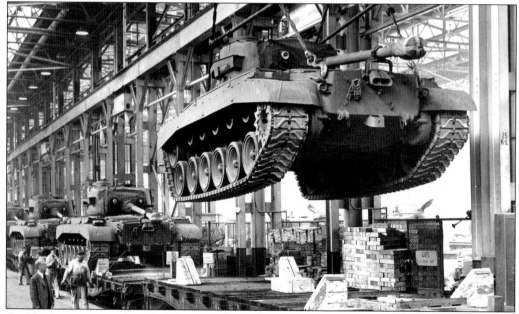

America's answer to the tough big German panzer tanks was the M26 Pershing, shown here being loaded on railroad flatcars at the Detroit Arsenal Tank Plant early in 1945. They reached the European theater too late to help defeat Germany but became able fighters against Russian T-34 tanks used by the North Korean army in 1950. (NAHC.)

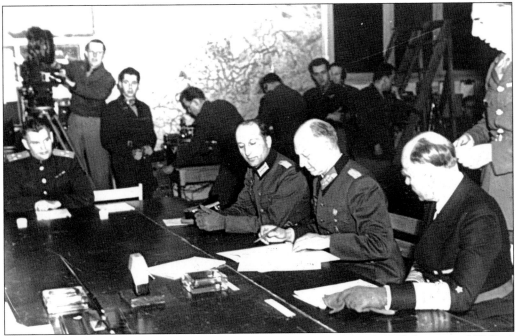

After nearly six years of war, Europe finally achieved peace on May 7, 1945, known as V-E Day. Germany's surrender came after Russian forces overwhelmed Berlin, Adolf Hitler committed suicide, and British and American troops swept through southern and northern Germany. Surviving German generals sign surrender documents in this ceremony in France early on the morning of May 7. In the Pacific, some of the bitterest combat of the war continued. (FDR.)

Just as Ford had been last in the industry to cease civilian production, it was also the first to resume it: this carryover 1942 pickup truck was assembled from stored parts at the Rouge plant on May 3, 1945, and designated as Ford's 31 millionth vehicle. The 30 millionth Ford had been a 1941 Ford station wagon that was donated to the American Red Cross. (JKW.)

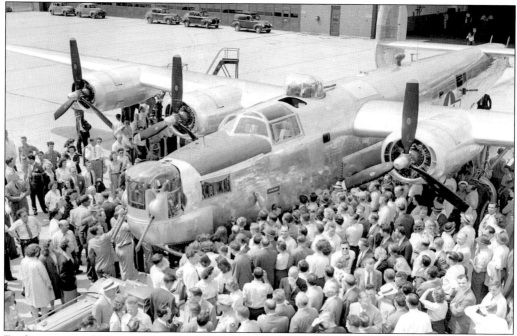

Ford's most notable wartime achievement was mass production of B-24 bombers at the Willow Run plant, west of Detroit, beginning in 1942. These workers are shown on June 28, 1945, autographing the final B-24 built: No. 8,685. Postwar, Kaiser-Frazer took over the plant to build cars until the mid-1950s when GM acquired it to manufacture automatic transmissions. (WPRL.)

Henry Ford II replaced his grandfather as president of Ford Motor Company on September 21, 1945. Among his ceremonial duties was presenting Ford's (and the industry's) first postwar passenger car to Pres. Harry S. Truman. The car's assembly had actually been completed on July 3, six weeks before war's end. (MS.)

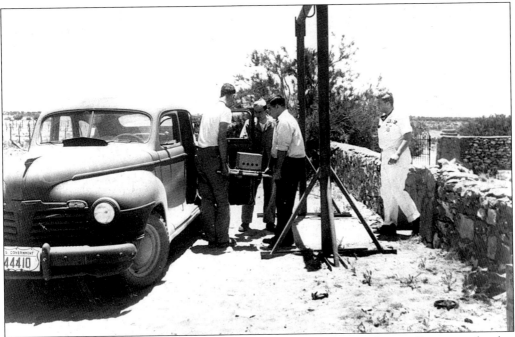

Chrysler engineers worked under government contract on the Manhattan Project to develop atomic bombs. By chance, an indirect contribution came when government scientists at Los Alamos, New Mexico, chose to carry the plutonium heart of the first bomb some 330 miles to the Alamogordo test site in a 1942 Plymouth army staff car. Here the scientists lift the device from the backseat the day before the atomic age dawned. (NAM.)

The end of World War II was wildly celebrated among the victorious around the world on the date Japan's agreement to surrender was announced, August 14, 1945, V-J Day. This crowd of young men and women somewhere on Detroit's east side overloaded a somewhat shopworn 1942 Ford convertible in their joy the night the war officially ceased. (WPRL.)

Toward the end of World War II, Ford issued this postcard illustration of its major war products: GPW jeep, GPA Seep, B-24 bomber, aircraft engine, glider, tank and tank destroyer, tank engine, armored cars, and other war equipment. It also had produced large quantities of aircraft superchargers and generators, tank armor, and militarized versions of civilian trucks and cars. Altogether Ford built some 413,000 vehicles in the United States for the Allied cause. (MS.)

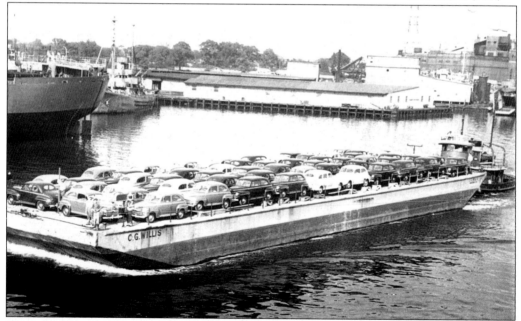

There was huge pent-up demand worldwide for new cars and trucks after World War II. This barge loaded with new 1946 Fords is being moved through an eastern U.S. waterway. Continuing material shortages caused many other 1946 model cars to be assembled with wooden beams in place of chromed bumpers. The beams were replaced months or even years later when chromed bumpers again became available. (MS.)

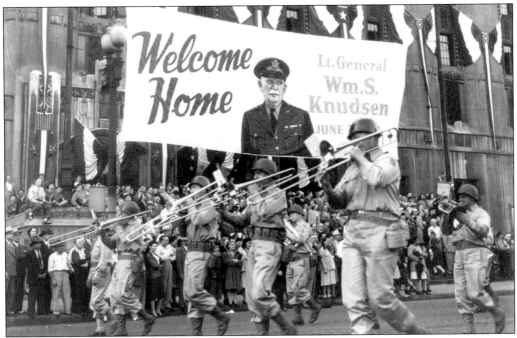

On June 1, 1945, while the war was still being waged in the Pacific, Lt. Gen. William S. Knudsen's fellow Detroiters recognized his service with a unique parade honoring him. This U.S. Army band is marching past a huge sign along Woodward Avenue in downtown Detroit. At Pres. Franklin D. Roosevelt's request in May 1940, Knudsen had resigned as president of GM to lead the nation's defense production. (GMCMA.)

Knudsen stands here at the center of the parade's reviewing stand in front of Detroit's old city hall. The presence on the dais of Undersecretary of War Robert P. Patterson, Michigan governor Harry Kelly, army chief of staff Gen. George C. Marshall Jr., and Michigan senator Homer Ferguson shows the local and national esteem in which Knudsen was held. (GMCMA.)

Like most other warriors after the war ended, the amphibious DUKW truck was relieved of active duty and discharged to fulfill civilian occupations. Here a DUKW parades postwar in Pontiac, where it was built, to promote enlistments in the U.S. Naval Reserve. Others became features of vacation resorts. DUKWs were called back to duty in the 1950–1953 Korean War along with other World War II veterans. (NAHC.)

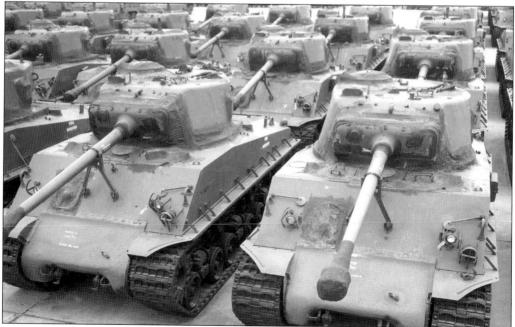

The best American World War II military equipment, such as these advanced M4 tanks with 90-millimeter cannon and cast and welded bodies, were mothballed in U.S. Army storage yards in the hope that, except for possible training, they would never have to be used again. That hope died when North Korea invaded South Korea in 1950, and these M4s proved highly effective against the best Russian-made tanks used by the North Korean army. (NAHC.)

BIBLIOGRAPHY

Binder, Alan K., and Deebe Ferris, eds. *General Motors in the Twentieth Century*. Southfield, MI: Ward's Communications, Intertec Publishing, 2000.

Clive, Alan. *State of War: Michigan in World War II*. Ann Arbor, MI: University of Michigan Press, 1979.

Curtin, D. Thomas. *Men, Oil and War*. Chicago: Petroleum Industry Committee, 1946.

Davis, Michael W. R. *General Motors: A Photographic History*. Charleston, SC: Arcadia Publishing, 1999.

———. *Chrysler Heritage: A Photographic History*. Charleston, SC: Arcadia Publishing, 2001.

Davis, Michael W. R., and James K. Wagner. *Ford Dynasty: A Photographic History*. Charleston, SC: Arcadia Publishing, 2002.

Doyle, David. *Standard Catalog of U.S. Military Vehicles*. 2nd ed. Iola, WI: Krause Publications, 2003.

Geary, L. *Ford Military Vehicles*. Hornchurch, Essex, UK: Ian Henry Publications, 1983.

Hyde, Charles K. *Riding the Roller Coaster: A History of the Chrysler Corporation*. Detroit: Wayne State University Press, 2003.

Kidder, Warren Benjamin. *Willow Run: Colossus of American Industry*. Lansing, MI: self-published, 1995.

Kimes, Beverly, and Henry Austin Clark Jr. *Standard Catalog of American Cars 1805–1942*. Iola, WI: Krause Publications, 1985.

McCann, Hugh Wray. "Arsenal of Democracy: Retooling for Tanks, Victory 'Garden.'" *Technology Century*. 1995: 204–207.

Nevins, Allan, and Frank Ernest Hill. *Ford: Expansion and Challenge 1915–1933*. New York: Charles Scribner's Sons, 1957.

———. *Ford: Decline and Rebirth 1933–1962*. New York: Charles Scribner's Sons, 1962.

Sloan, Alfred P., Jr. *My Years with General Motors*. New York: Doubleday and Company, 1964.

Snider, Clare J., and Michael W. R. Davis. *The Ford Fleet, 1923–1989*. Cleveland: Freshwater Press, 1994.

Sorenson, Charles E., and Samuel T. Williamson. *My Forty Years with Ford*. New York: W. W. Norton and Company, 1956.

Wrynn, V. Dennis. *Detroit Goes to War: The American Auto Industry in World War II*. Osceola, WI: Motorbooks International, 1993.